THE INFLATABLES
in BAD AIR DAY

By Beth Garrod & Jess Hitchman
Illustrated by Chris Danger

Scholastic Inc.

To Gemma, who always pumps us up —BG & JH

**To Vanessa, Jaime, and
Vivienne Poet Rodriguez —CD**

ISBN 978-1-338-74897-0

10 9 8 7 6 5 4 3 2 22 23 24 25 26

Printed in the U.S.A. 37

First printing 2022

Book design by Stephanie Yang

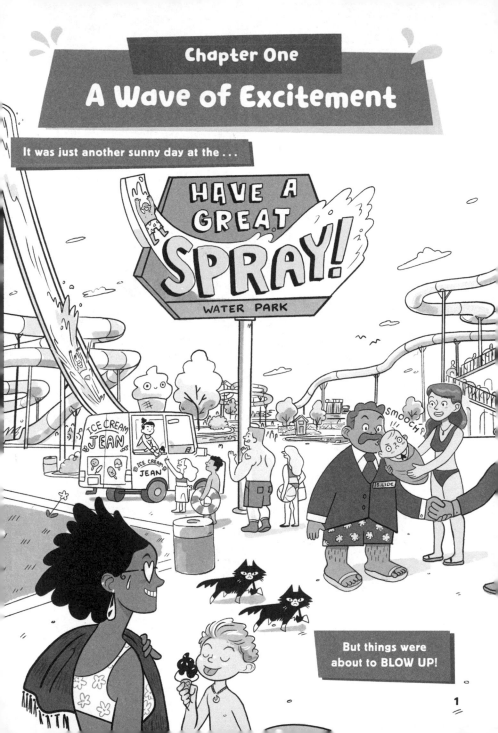

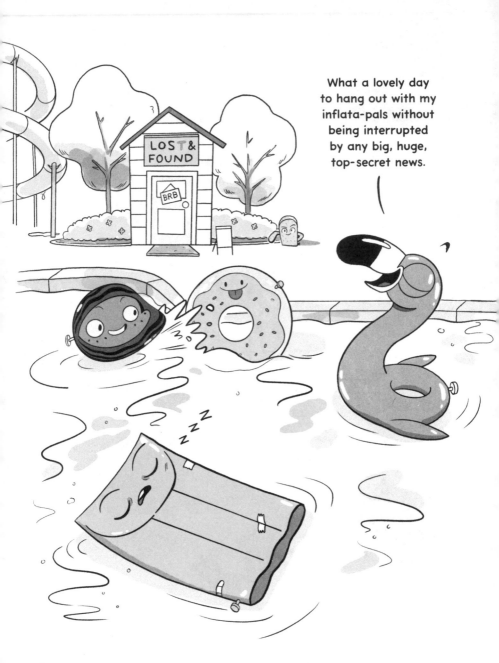

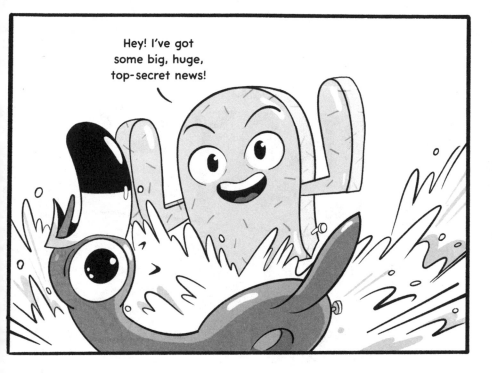

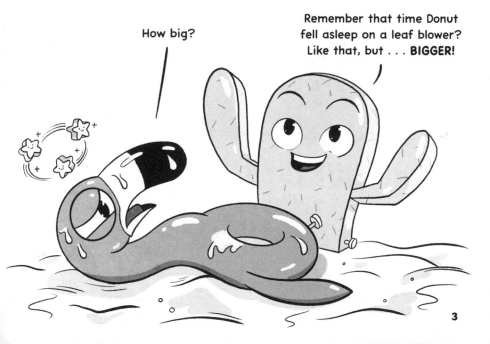

3

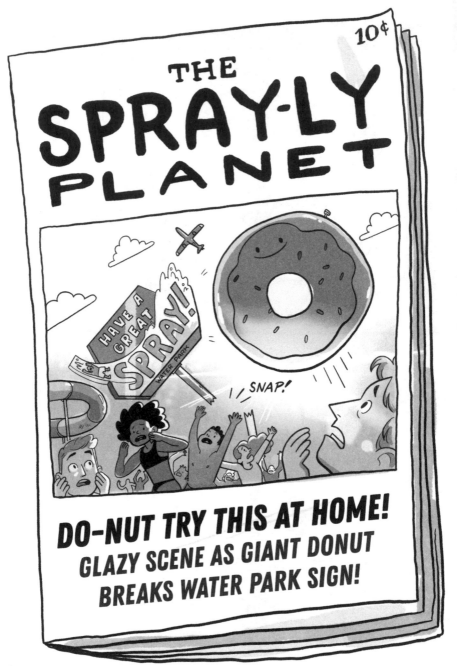

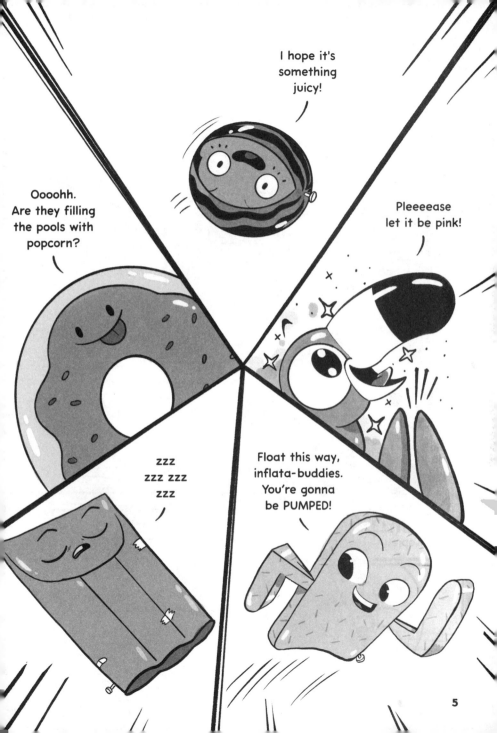

5

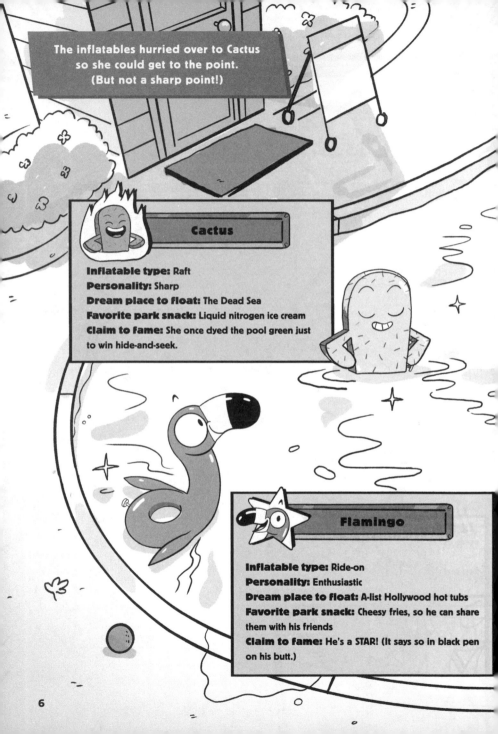

The inflatables hurried over to Cactus so she could get to the point. (But not a sharp point!)

Cactus

Inflatable type: Raft
Personality: Sharp
Dream place to float: The Dead Sea
Favorite park snack: Liquid nitrogen ice cream
Claim to fame: She once dyed the pool green just to win hide-and-seek.

Flamingo

Inflatable type: Ride-on
Personality: Enthusiastic
Dream place to float: A-list Hollywood hot tubs
Favorite park snack: Cheesy fries, so he can share them with his friends
Claim to fame: He's a STAR! (It says so in black pen on his butt.)

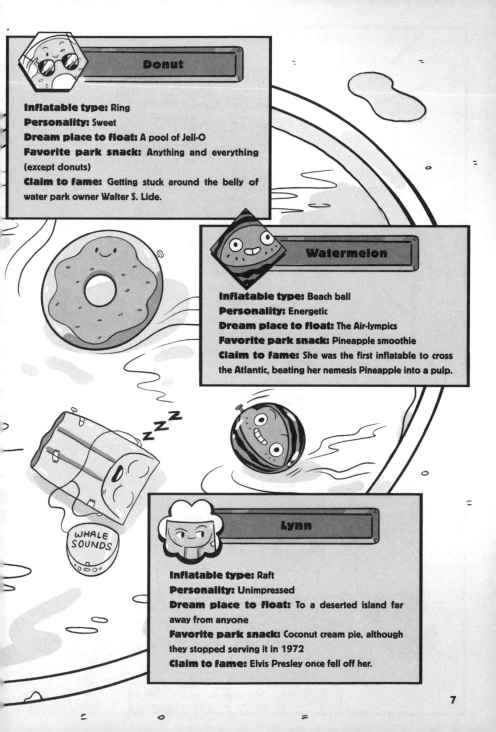

Donut

Inflatable type: Ring
Personality: Sweet
Dream place to float: A pool of Jell-O
Favorite park snack: Anything and everything (except donuts)
Claim to fame: Getting stuck around the belly of water park owner Walter S. Lide.

Watermelon

Inflatable type: Beach ball
Personality: Energetic
Dream place to float: The Air-lympics
Favorite park snack: Pineapple smoothie
Claim to fame: She was the first inflatable to cross the Atlantic, beating her nemesis Pineapple into a pulp.

Lynn

Inflatable type: Raft
Personality: Unimpressed
Dream place to float: To a deserted island far away from anyone
Favorite park snack: Coconut cream pie, although they stopped serving it in 1972
Claim to fame: Elvis Presley once fell off her.

WHALE SOUNDS

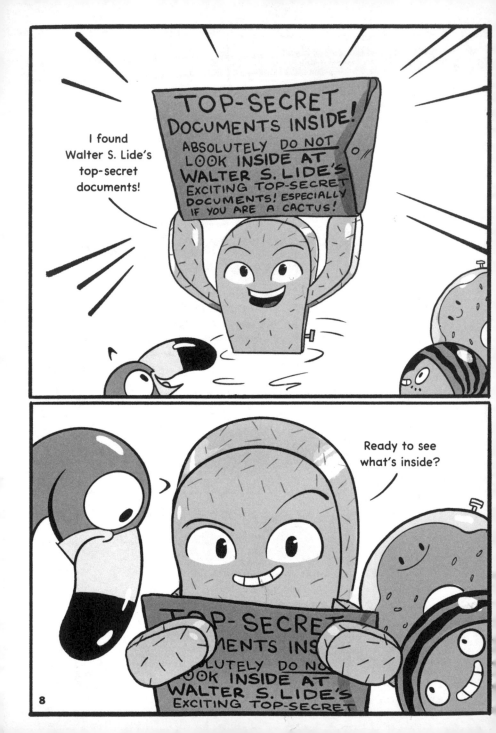

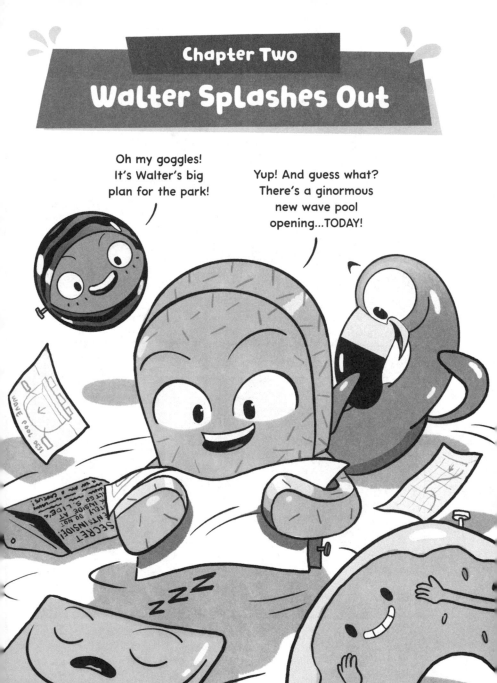

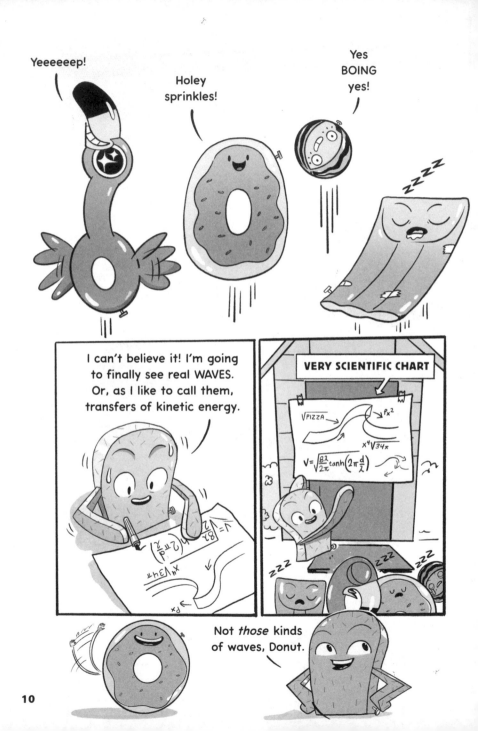

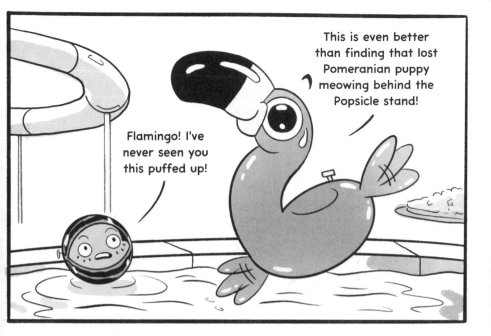

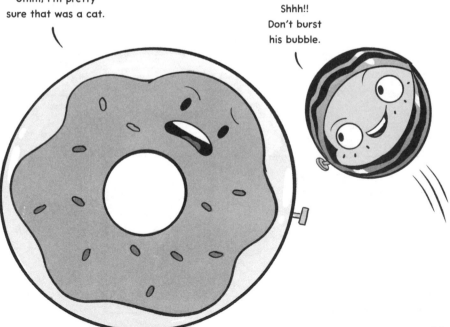

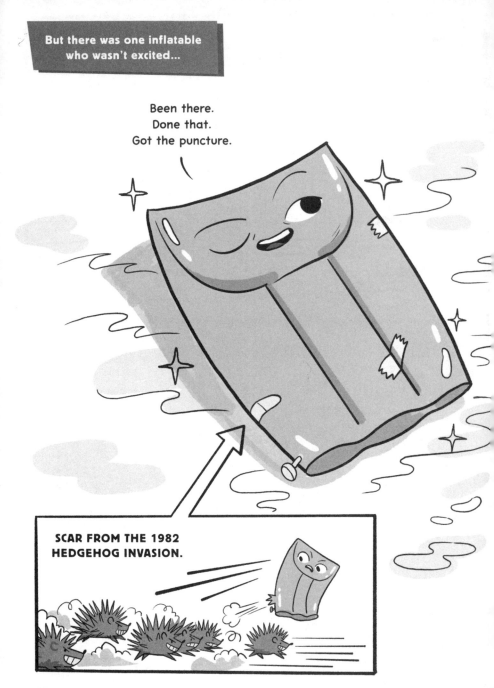

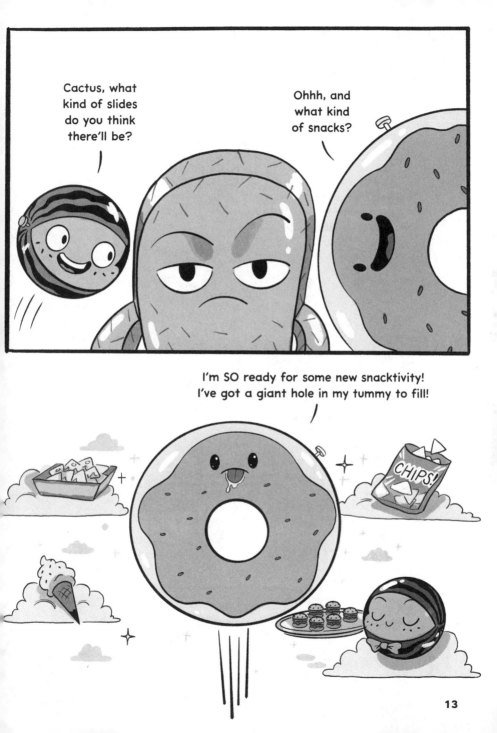

13

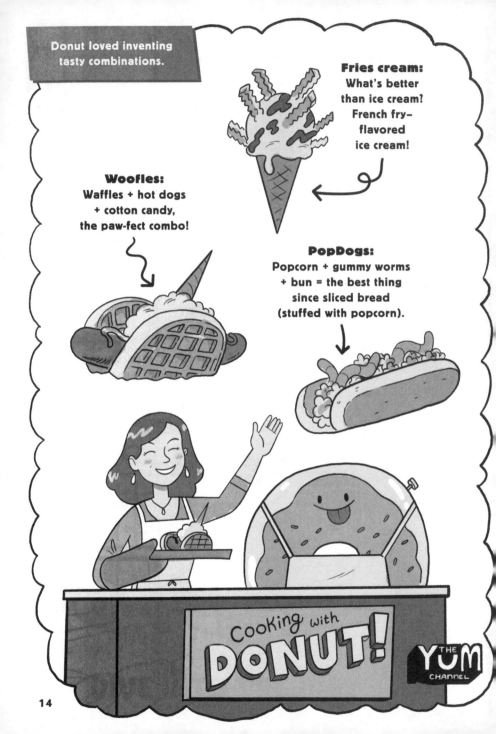

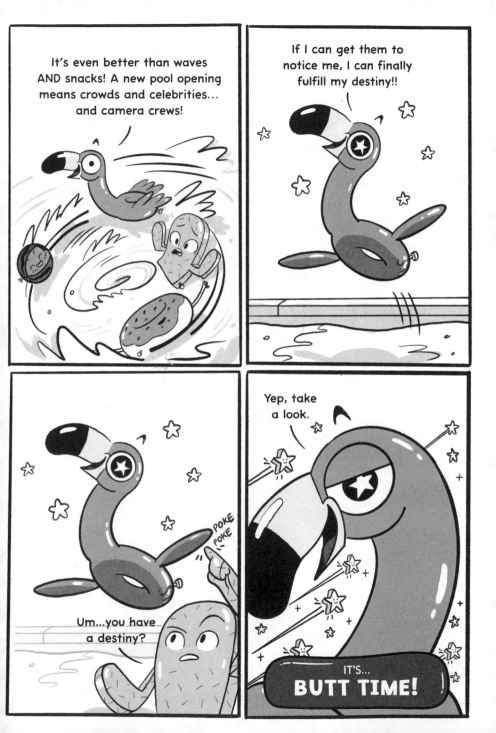

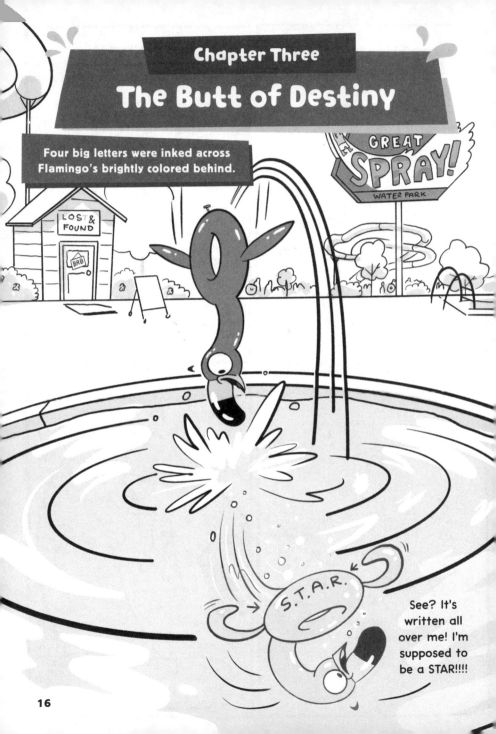

Chapter Three
The Butt of Destiny

Four big letters were inked across Flamingo's brightly colored behind.

See? It's written all over me! I'm supposed to be a STAR!!!!

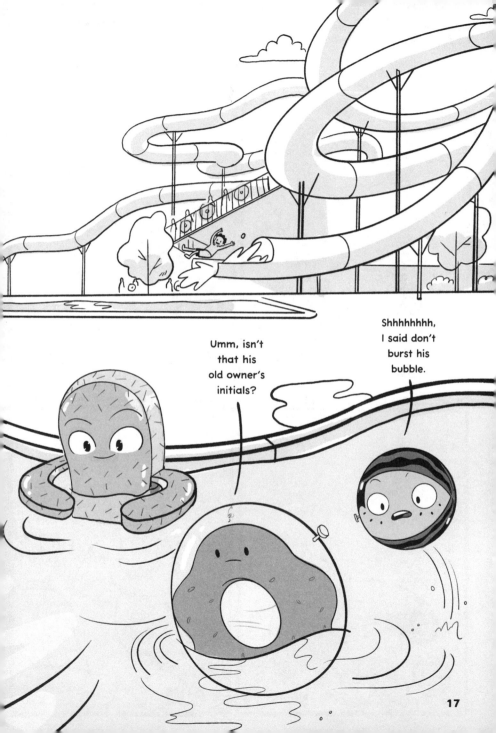

17

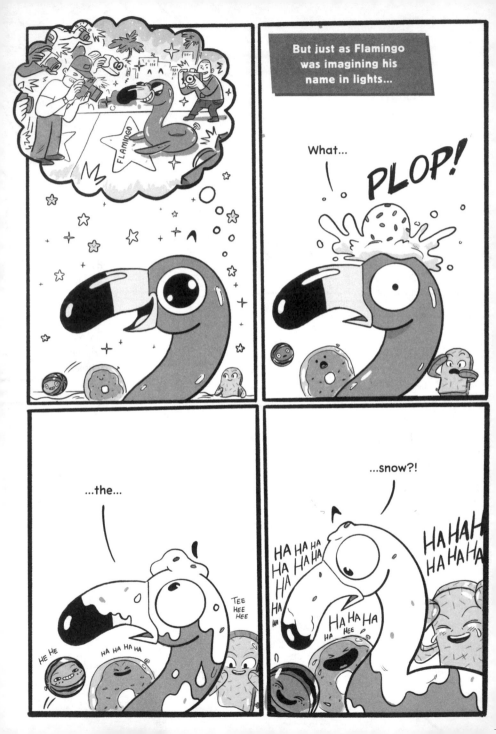

There's snow EVERYWHERE. And sprinkles. In the middle of summer. It's a magical winter wonderland miracle!

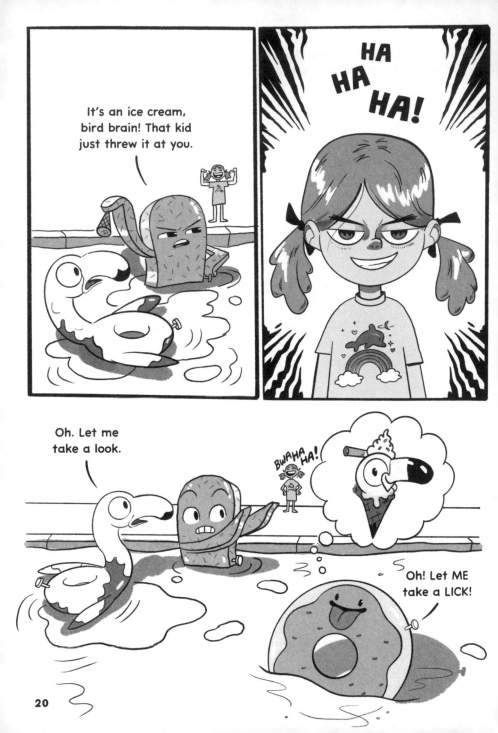

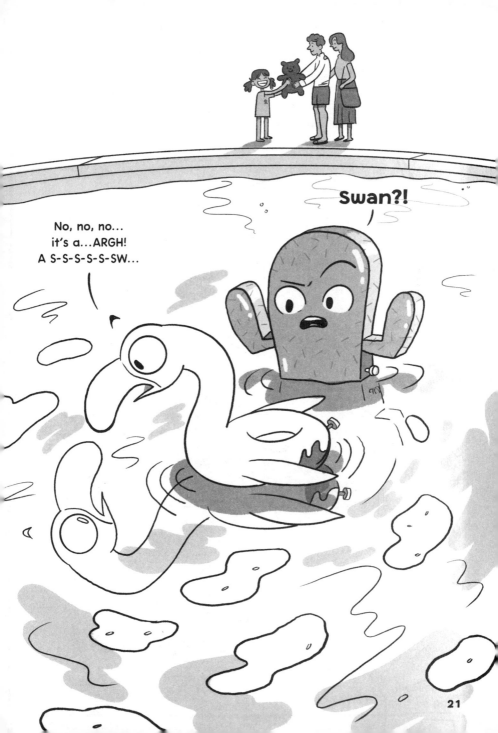

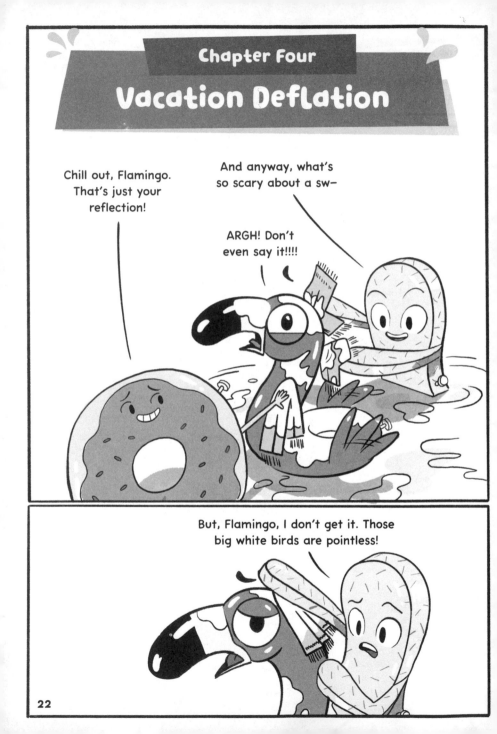

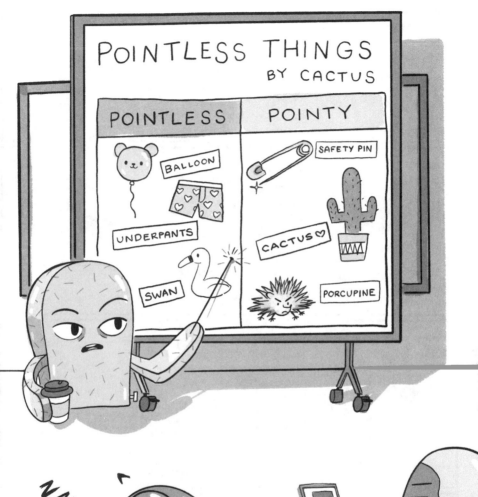

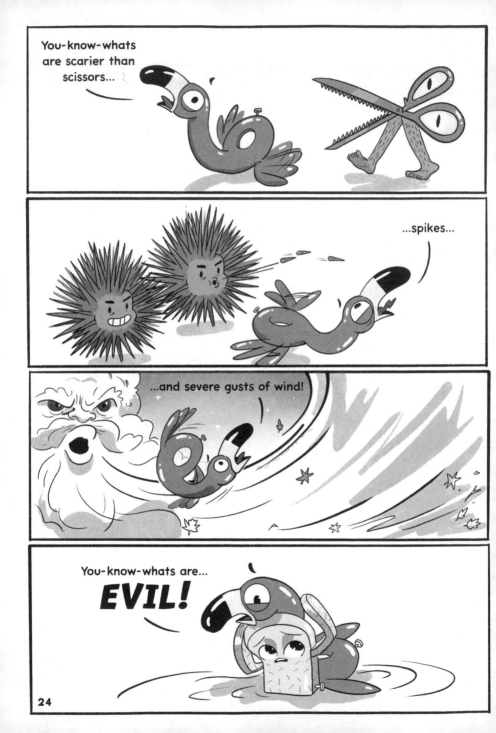

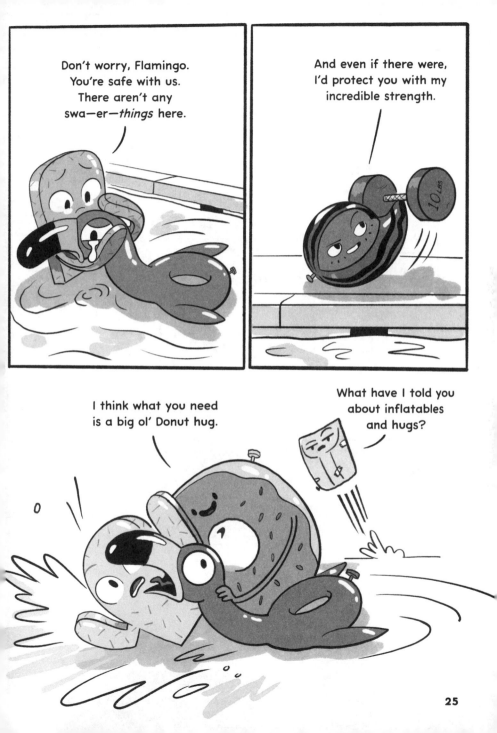

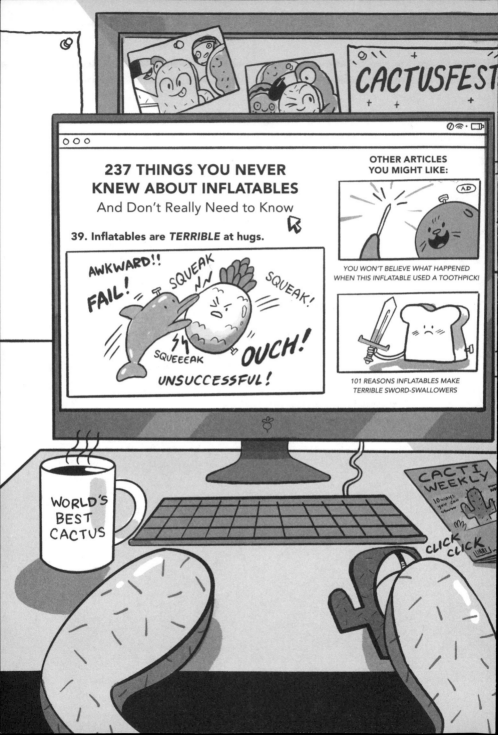

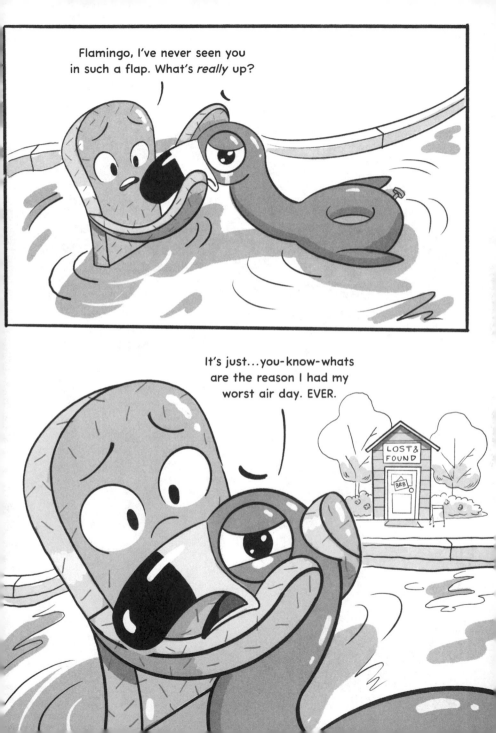

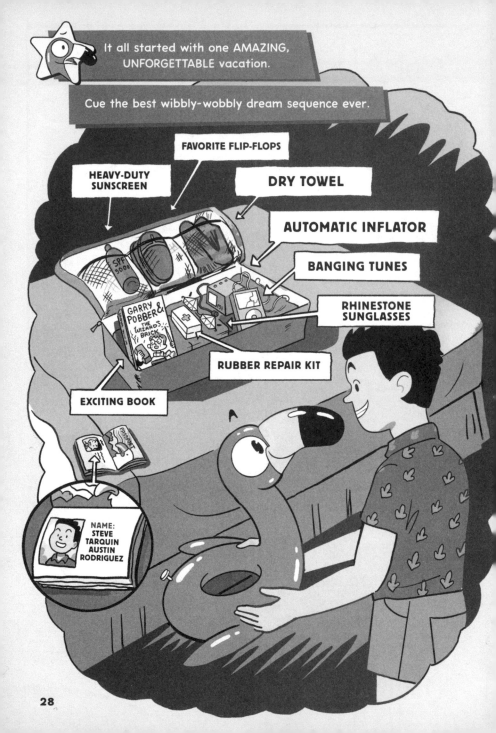

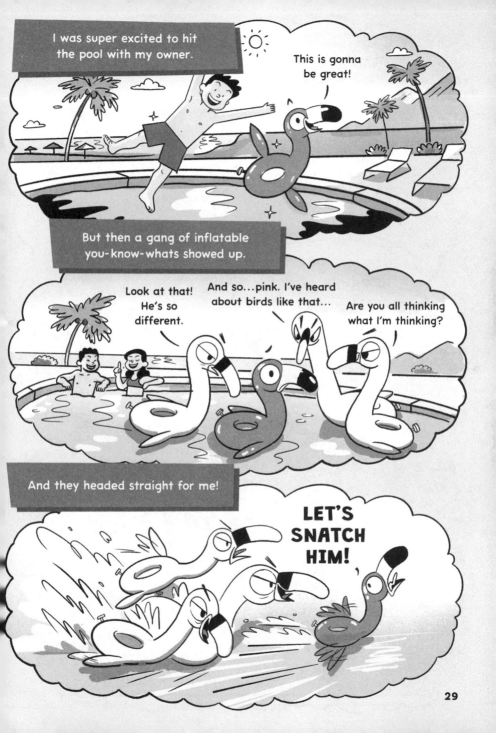

29

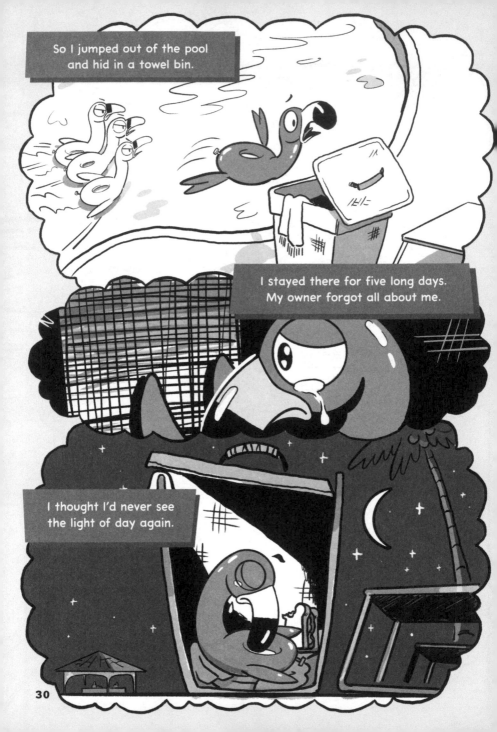

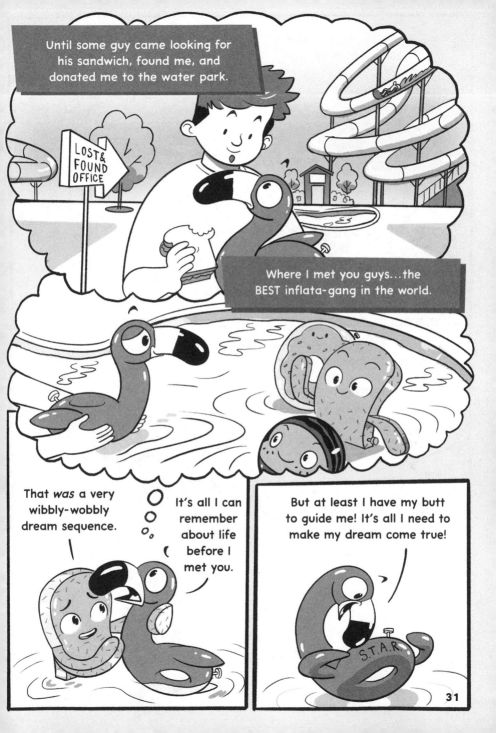

31

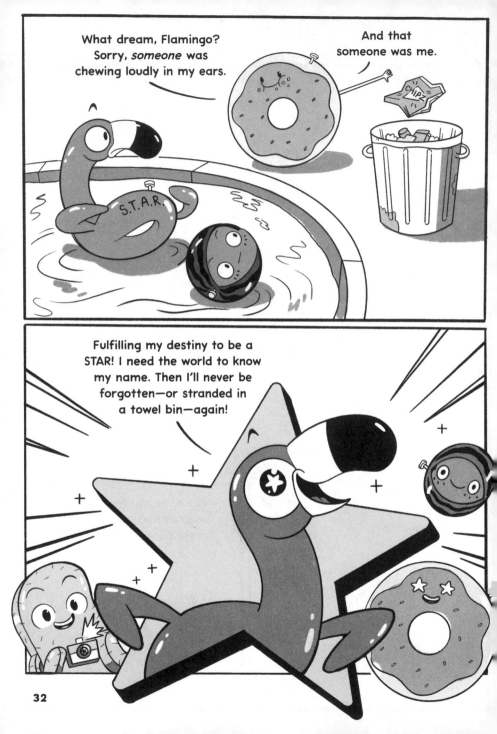

32

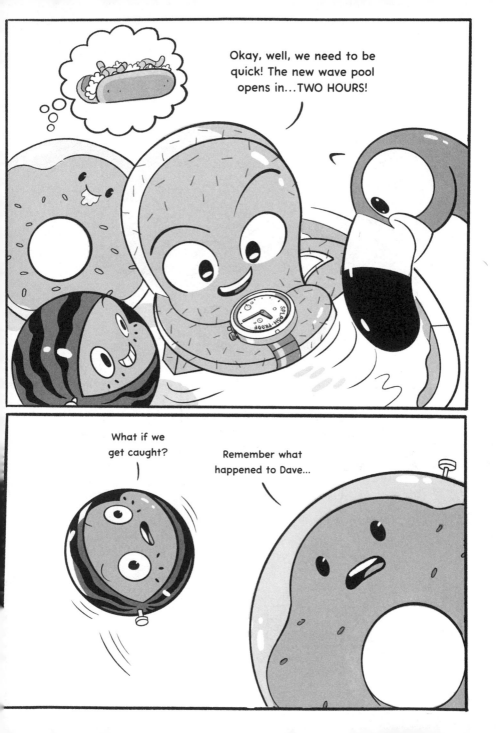

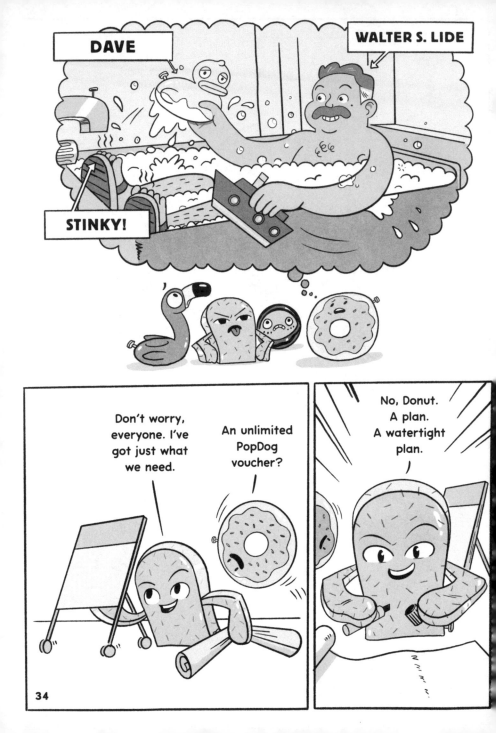

34

Undercover Pop-eration

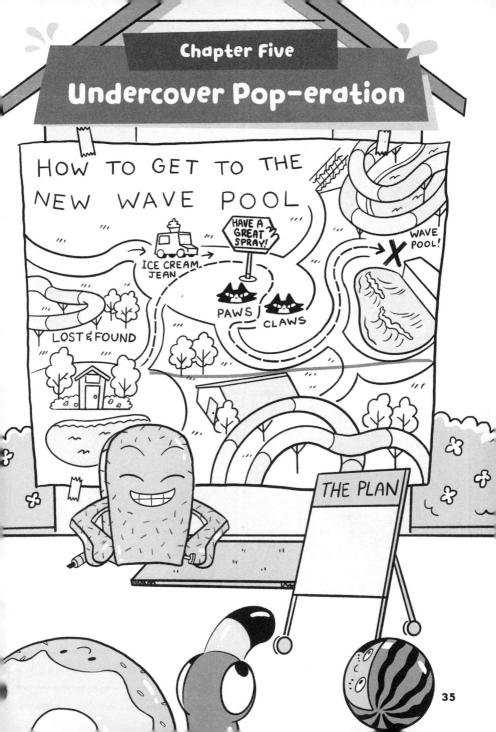

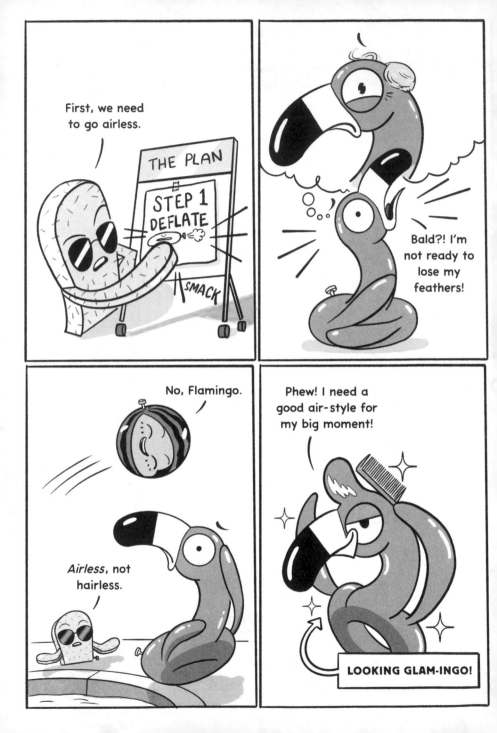

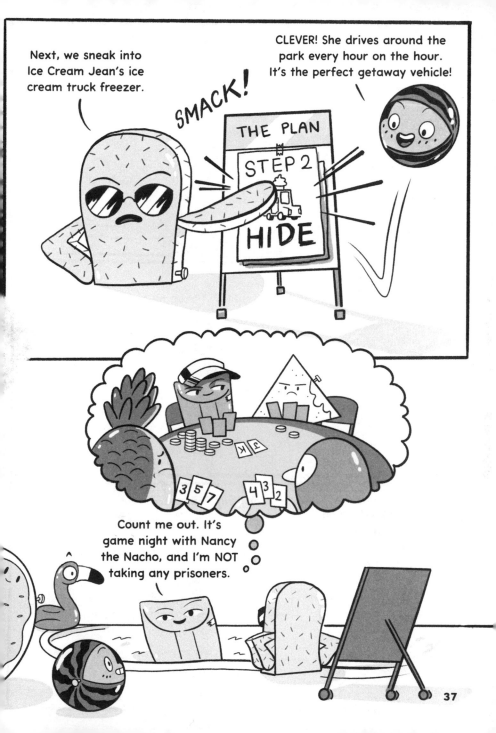

37

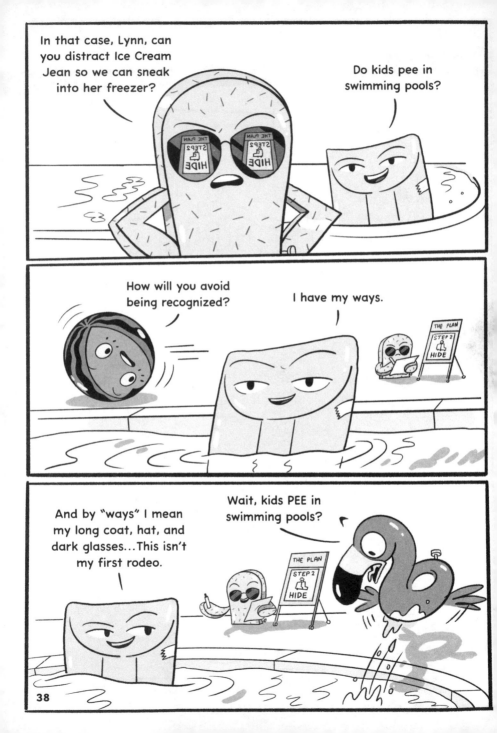

38

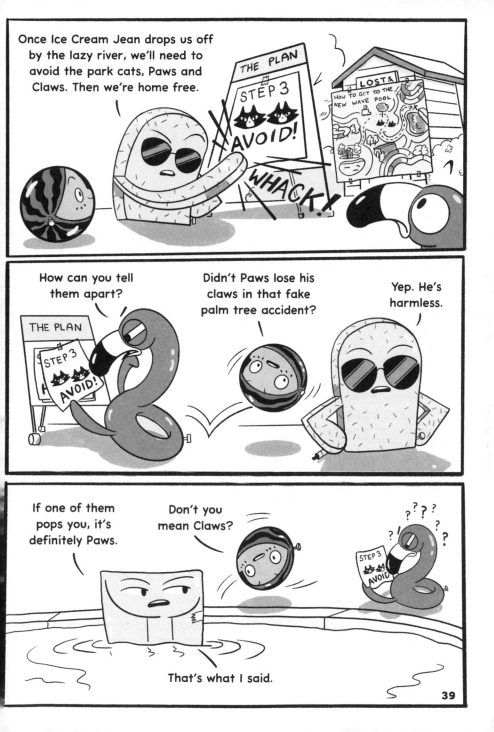

39

THE LAWS OF
PAWS AND CLAWS

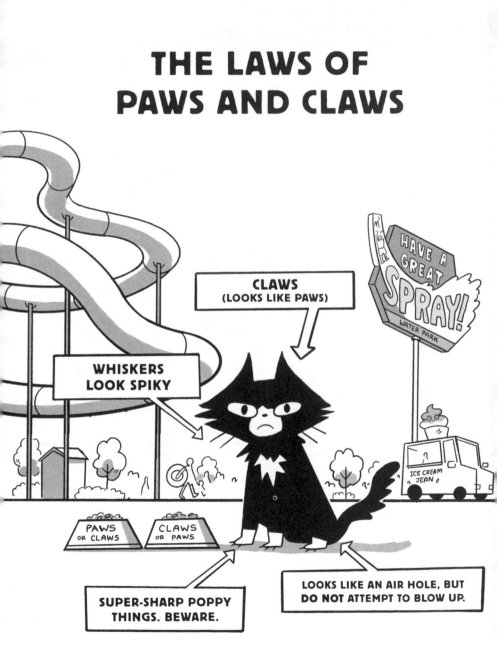

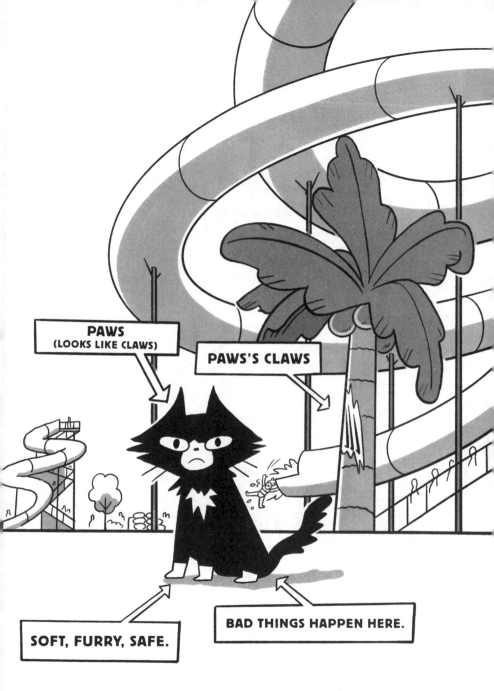

41

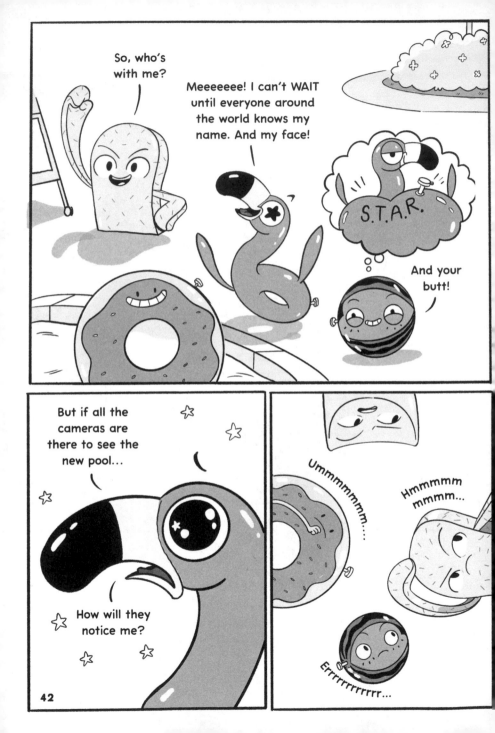

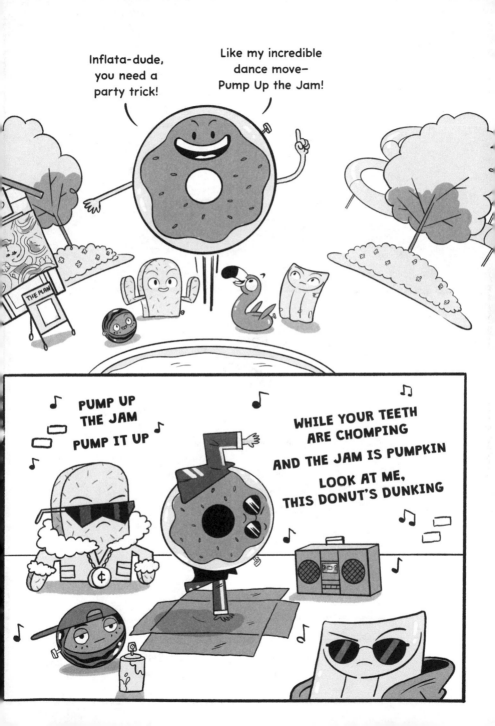

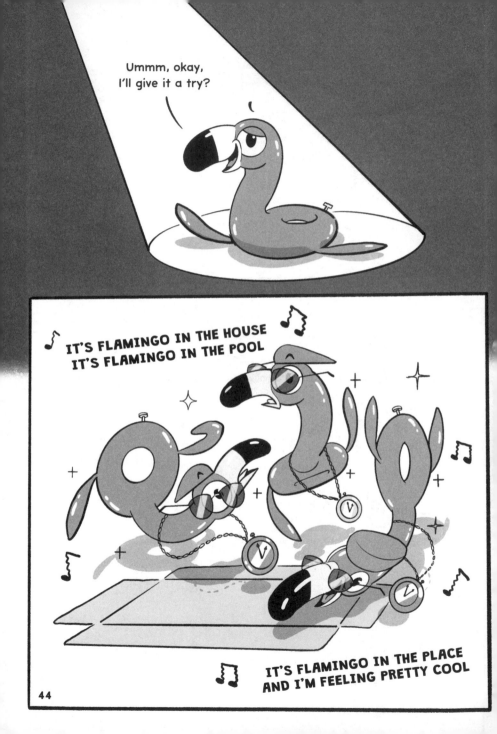

45

46

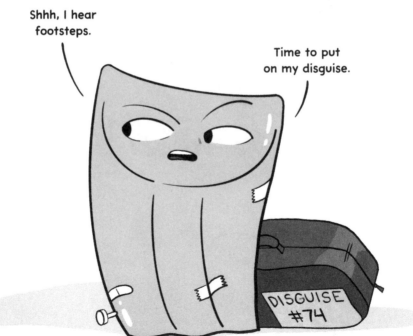

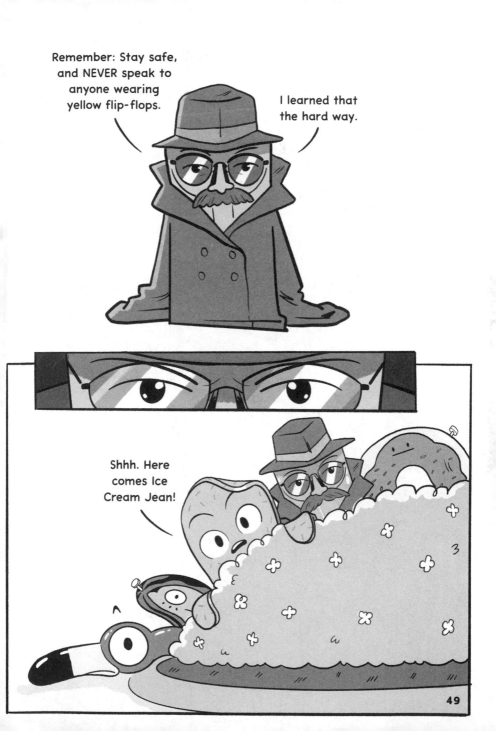

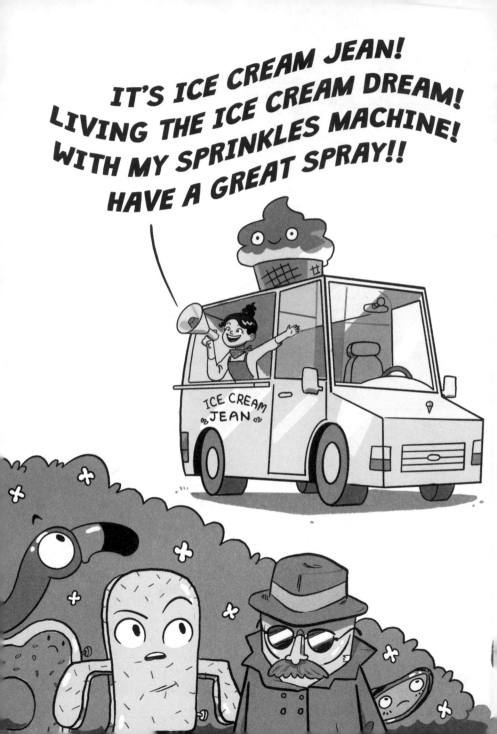

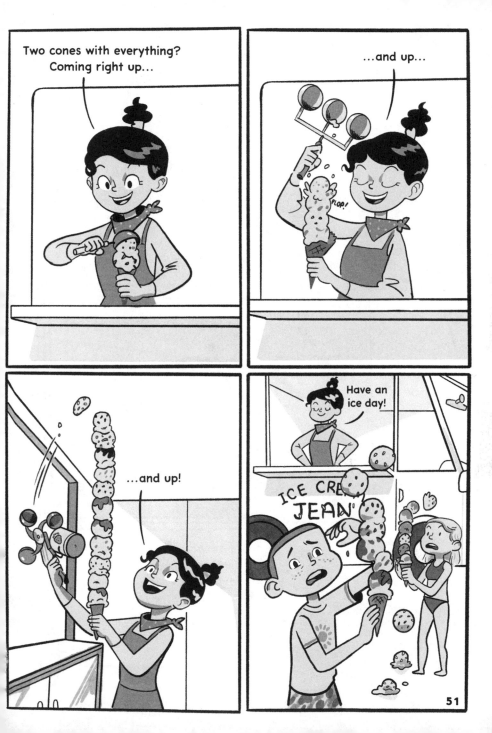

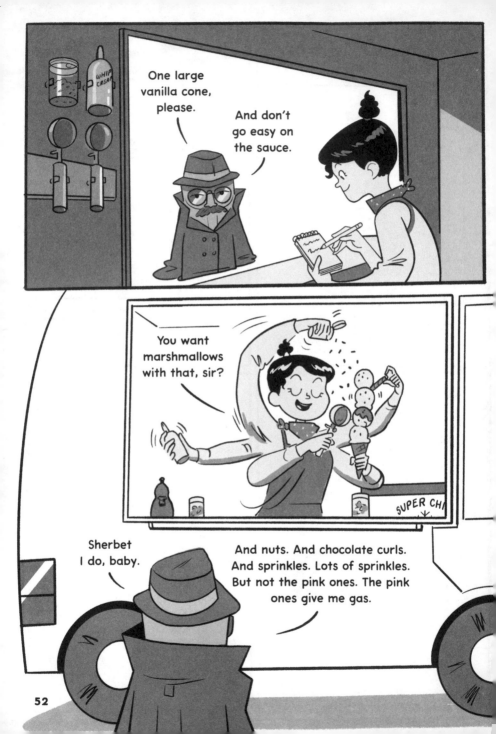

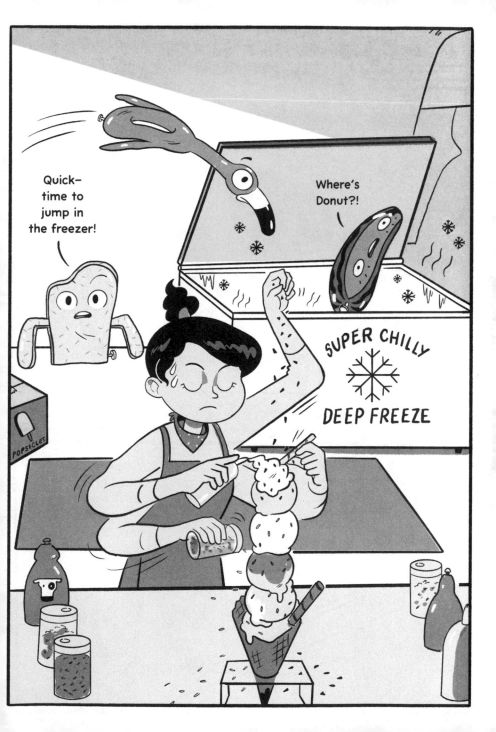

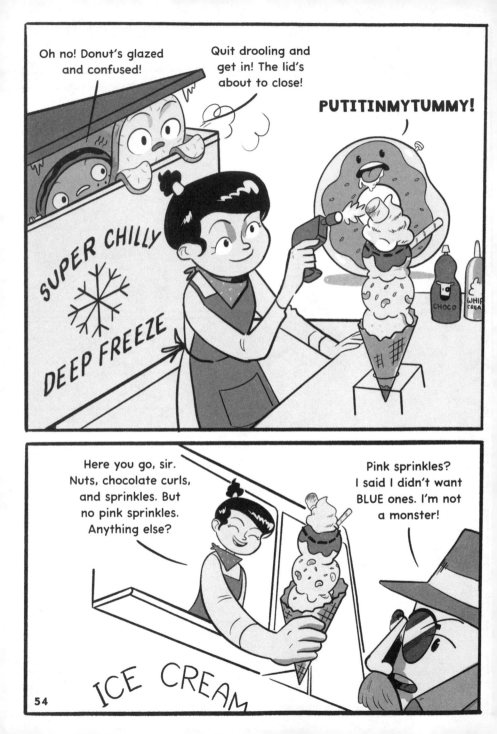

54

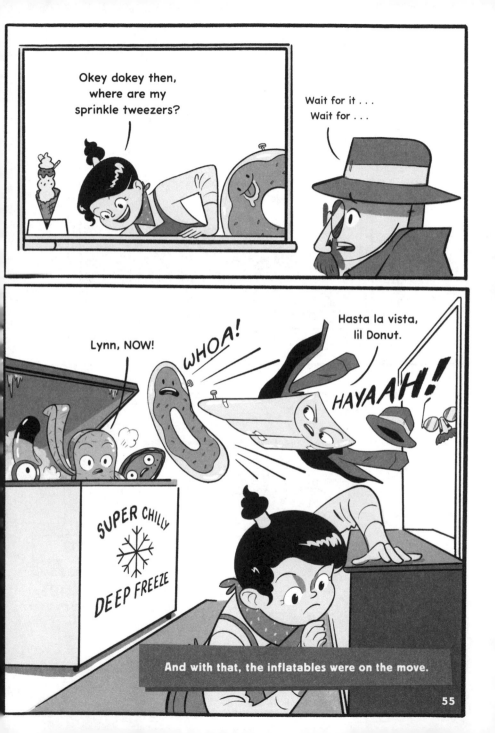

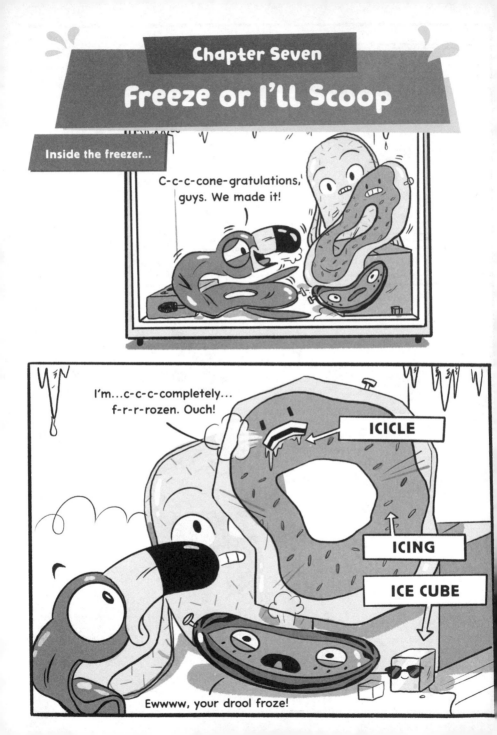

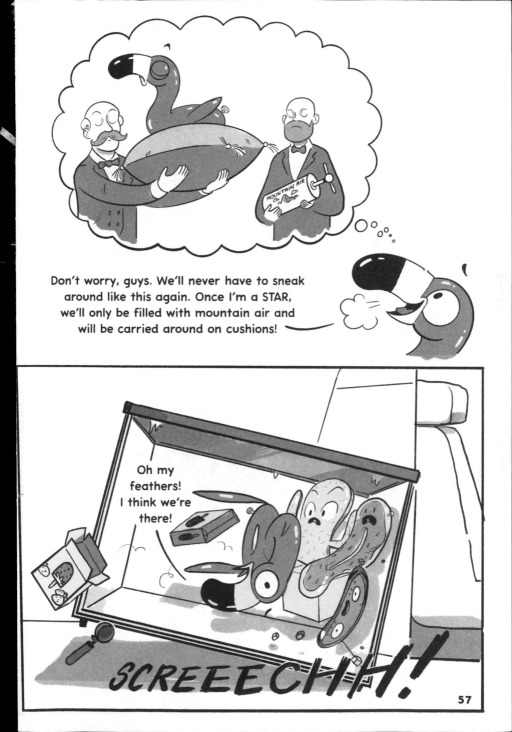

Don't worry, guys. We'll never have to sneak around like this again. Once I'm a STAR, we'll only be filled with mountain air and will be carried around on cushions!

MOUNTAIN AIR

Oh my feathers! I think we're there!

SCREEECHH!

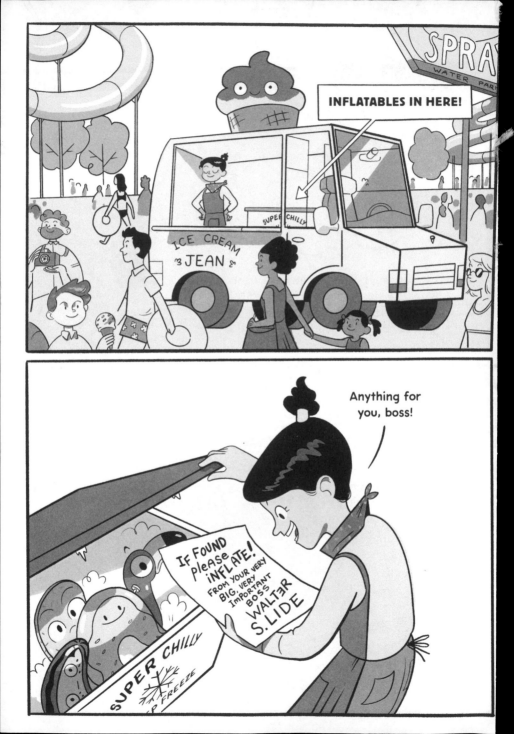

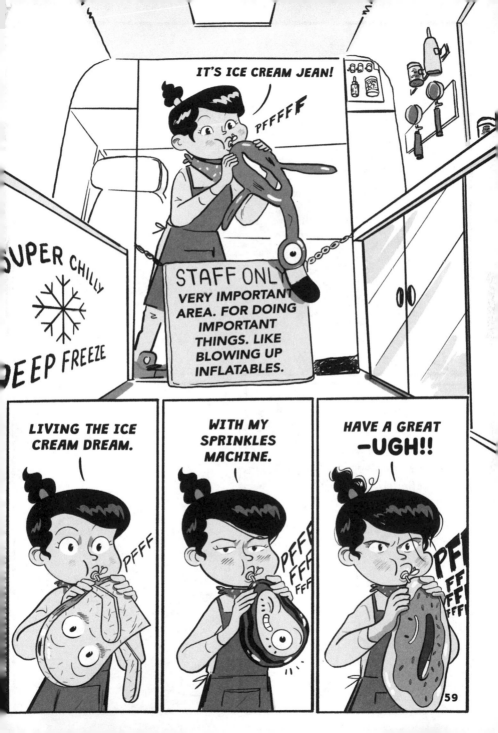

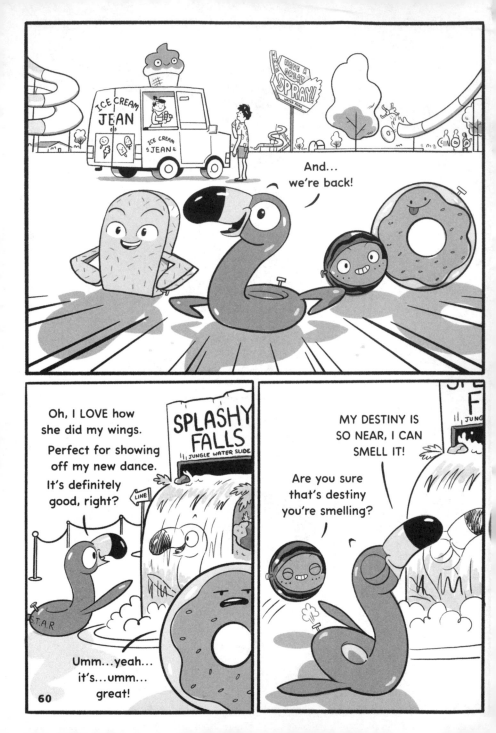

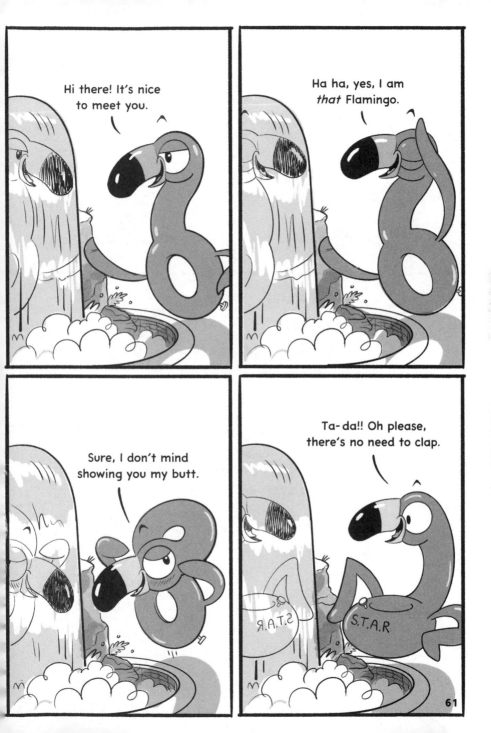

61

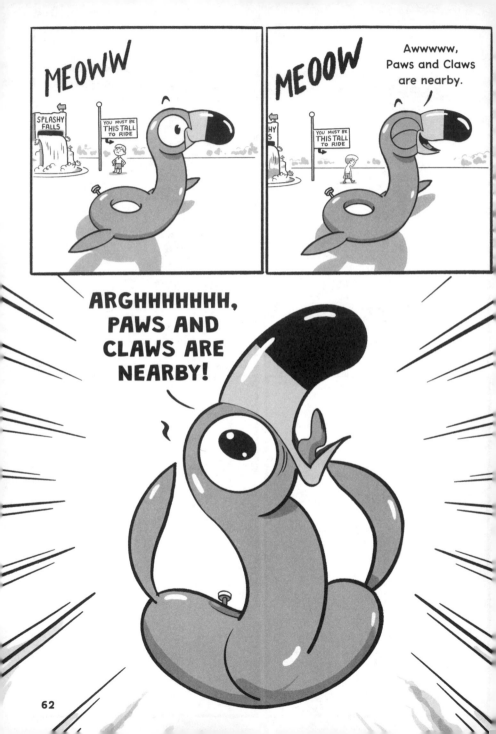

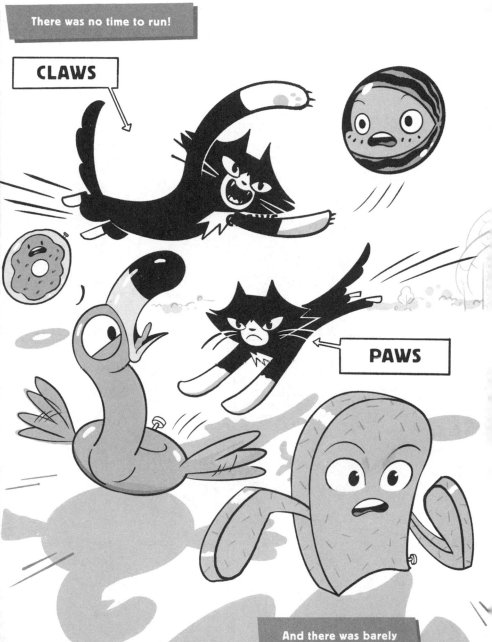

There was no time to run!

CLAWS

PAWS

And there was barely enough time to hide!

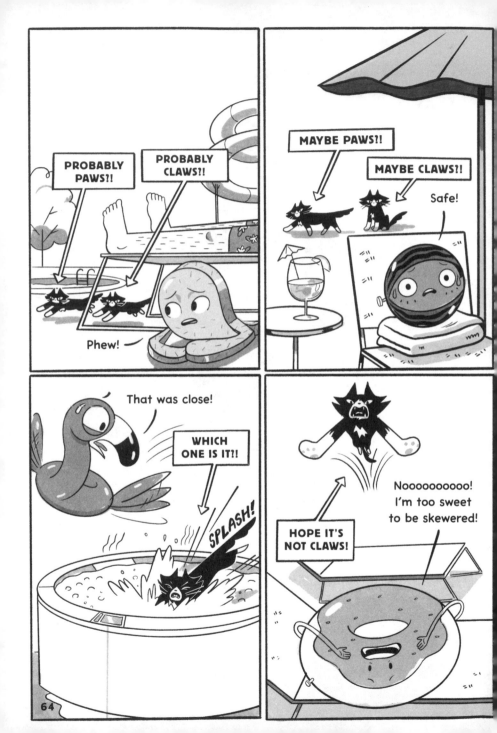

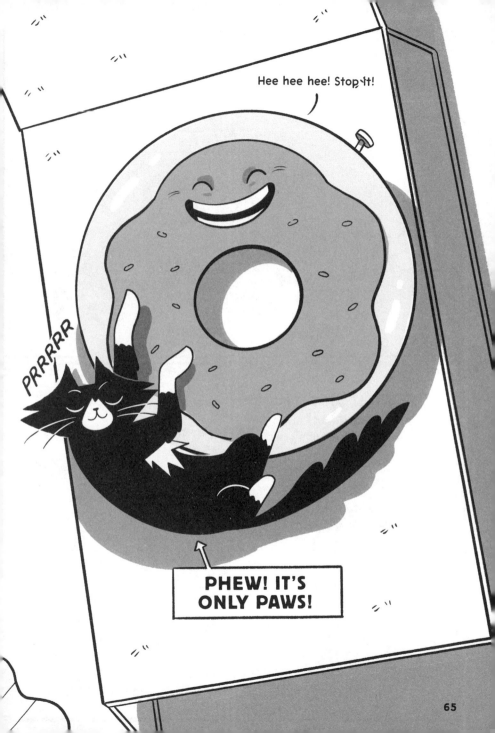

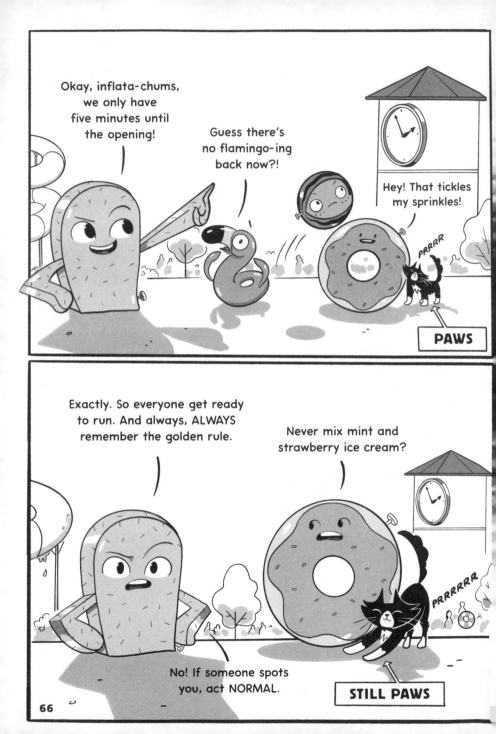

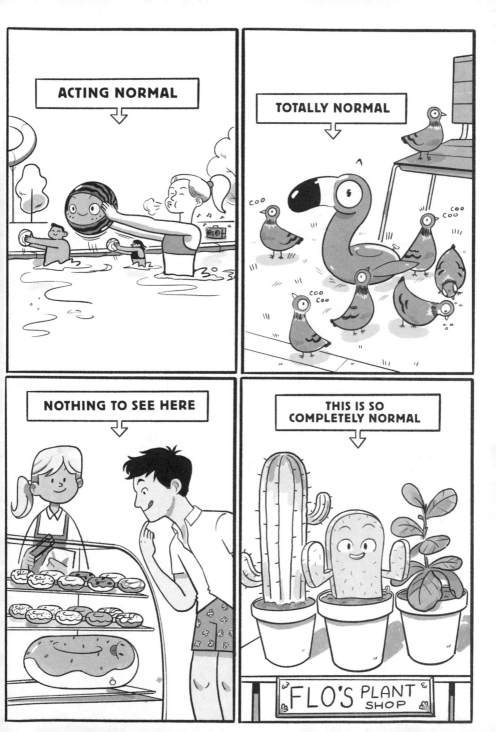

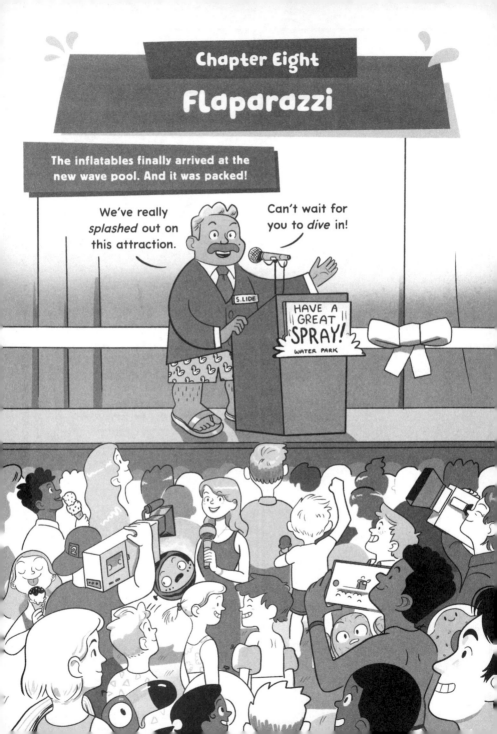

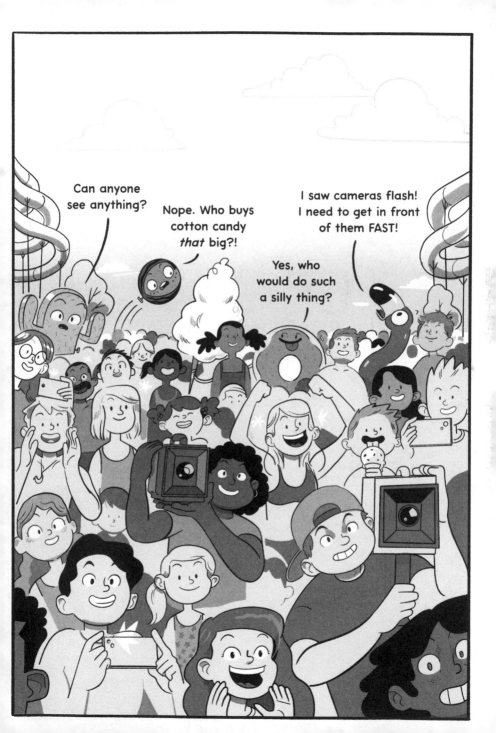

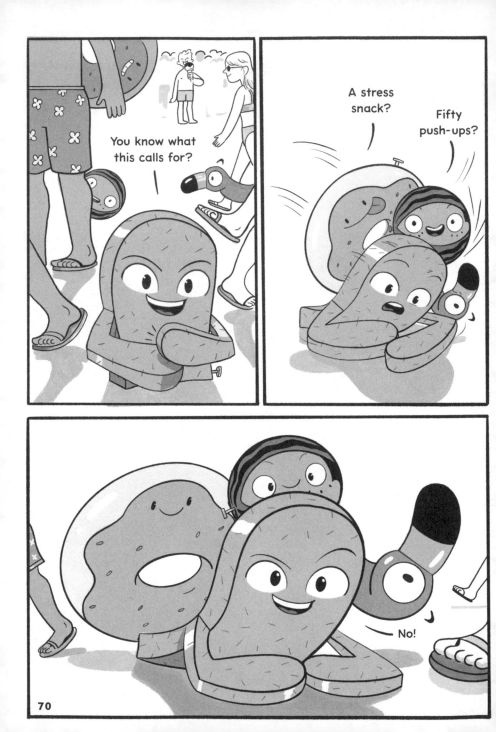

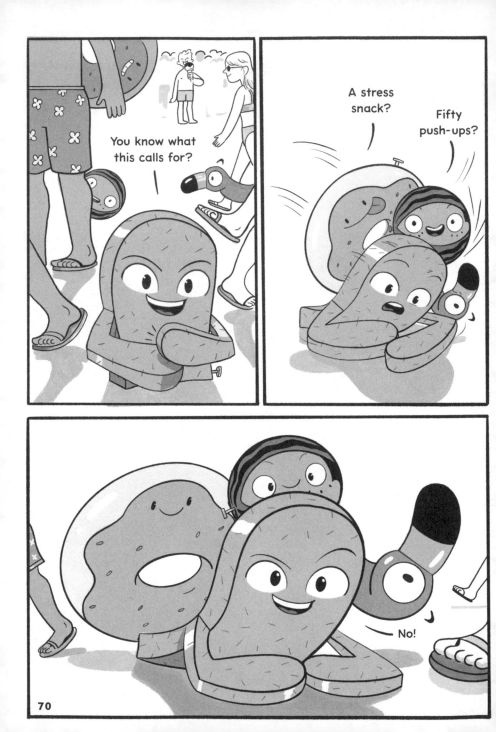

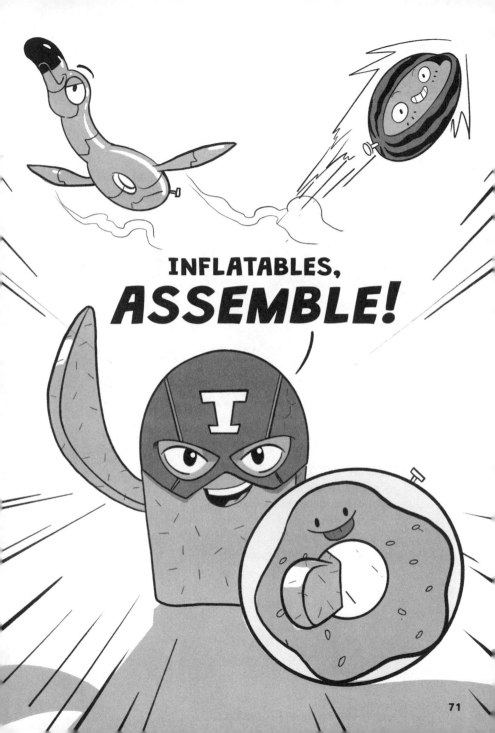

71

Cactus checked the handy-dandy *Big Book of Emergency Inflatable Formations* to find the perfect disguise.

GIANT BANANA FORMATION

Great for: Hiding near unusually large fruit

Pros: Can split quickly

Cons: Not very a-peel-ing and people try to eat you

SHARK FORMATION

Great for: Pulling a jaw-some prank in the pool

Pros: Fin-tastic way of petrifying people

Cons: Also frightens Flamingo

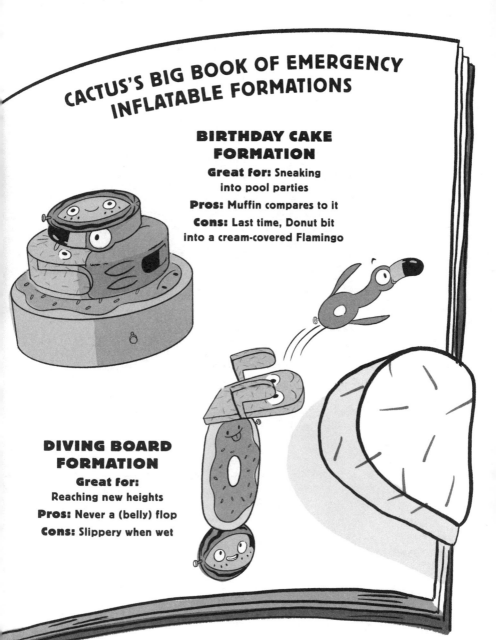

CACTUS'S BIG BOOK OF EMERGENCY INFLATABLE FORMATIONS

BIRTHDAY CAKE FORMATION

Great for: Sneaking into pool parties

Pros: Muffin compares to it

Cons: Last time, Donut bit into a cream-covered Flamingo

DIVING BOARD FORMATION

Great for: Reaching new heights

Pros: Never a (belly) flop

Cons: Slippery when wet

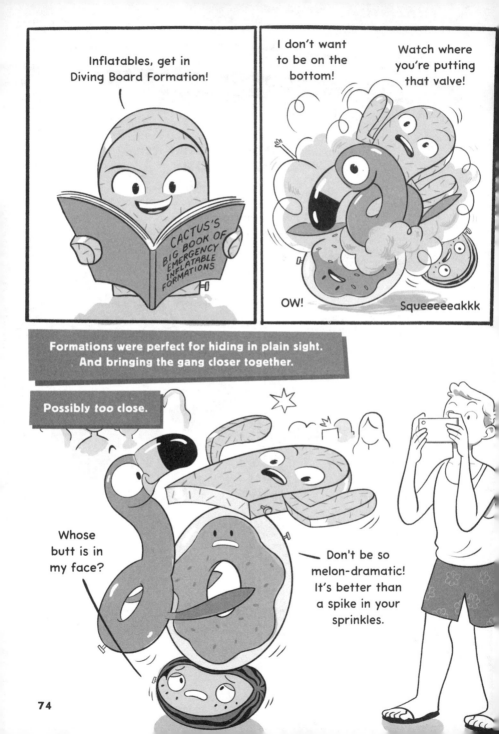

Inflatables, get in Diving Board Formation!

CACTUS'S BIG BOOK OF EMERGENCY INFLATABLE FORMATIONS

I don't want to be on the bottom!

Watch where you're putting that valve!

OW!

Squeeeeeakkk

Formations were perfect for hiding in plain sight. And bringing the gang closer together.

Possibly too close.

Whose butt is in my face?

Don't be so melon-dramatic! It's better than a spike in your sprinkles.

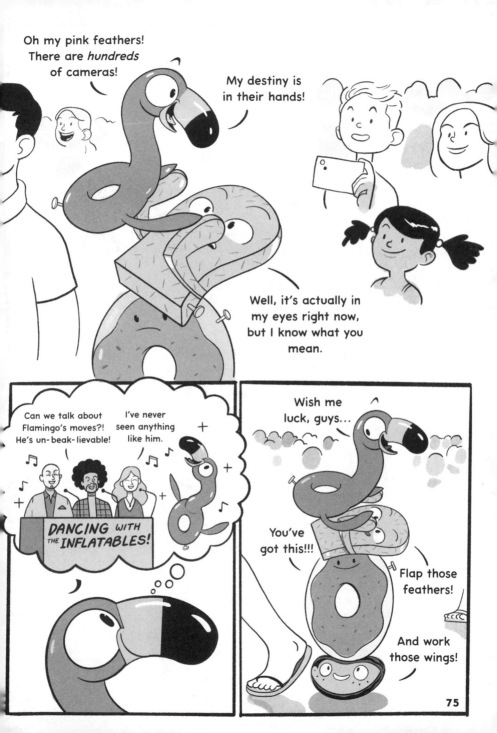

75

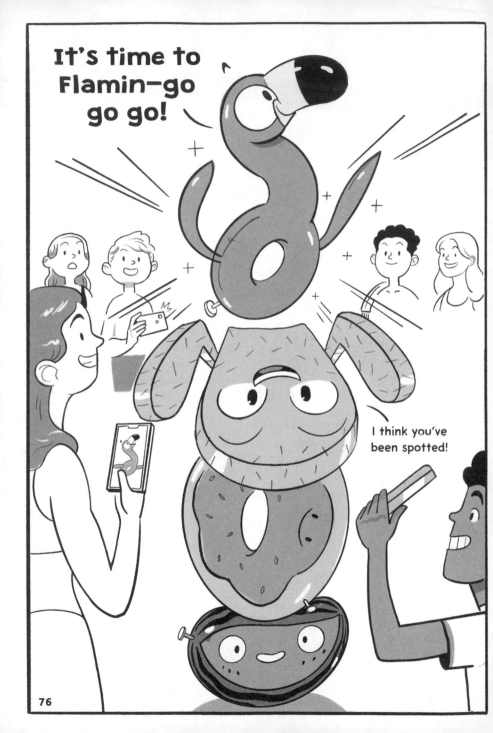

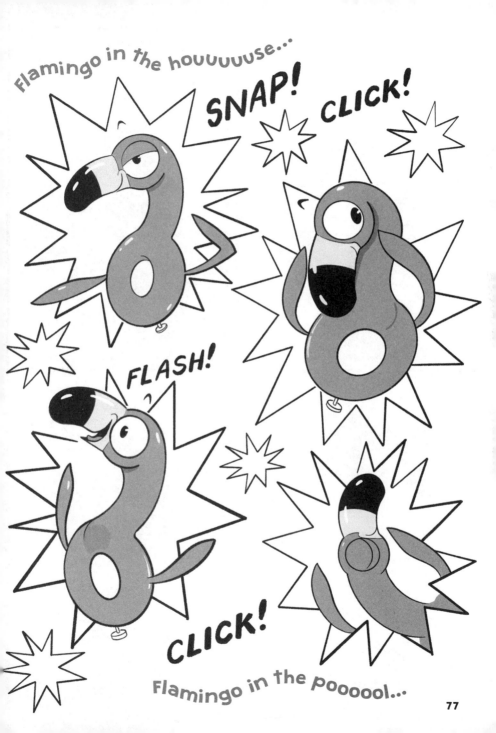

Did you see that?! It worked!!! I've been discovered! And now I'm going to be a STAR!!!

You're the best bunch of inflata-friends anyone could have. You guys ALWAYS lift me up! You are the rings beneath my wings.

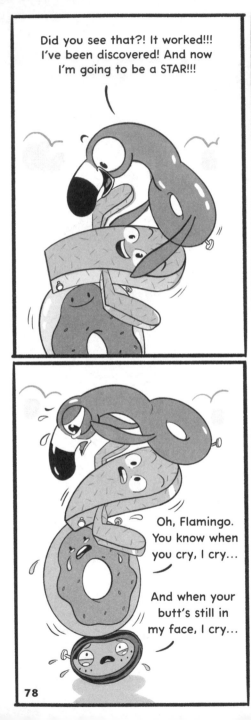

Oh, Flamingo. You know when you cry, I cry...

And when your butt's still in my face, I cry...

Pull yourselves together, inflata-peeps. Remember what happens when diving boards get wet? **They get slippery...**

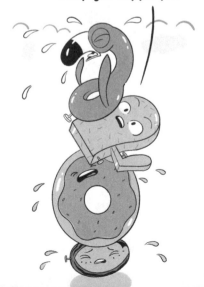

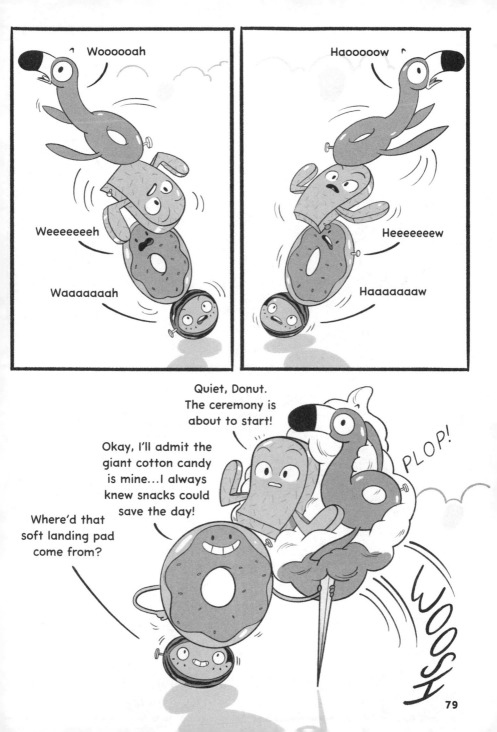

79

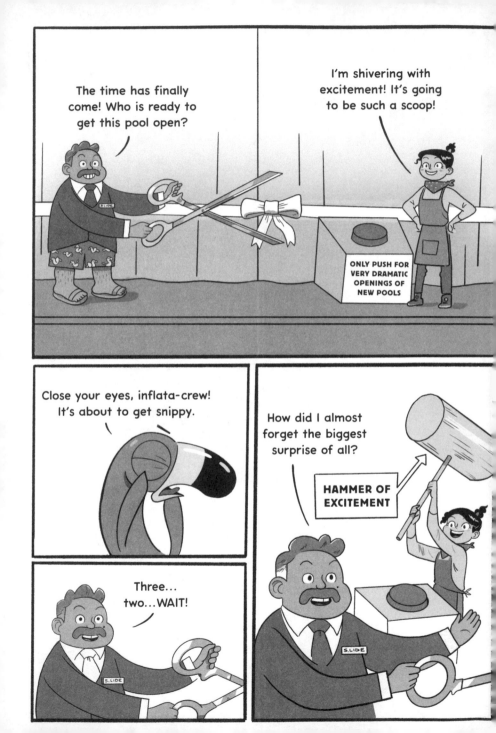

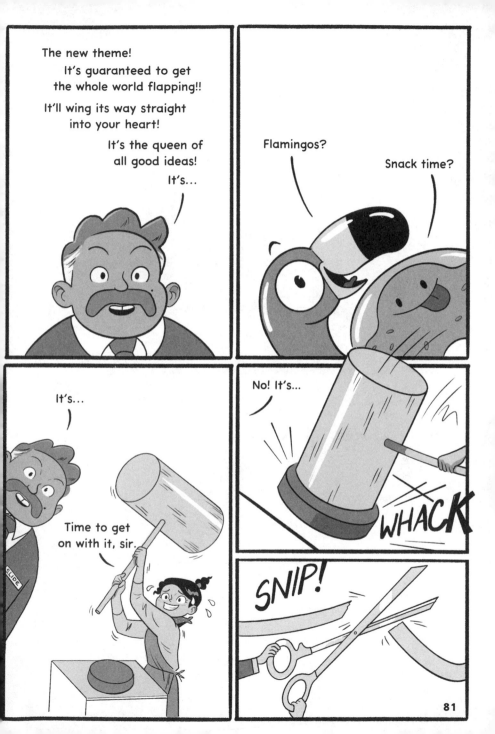

81

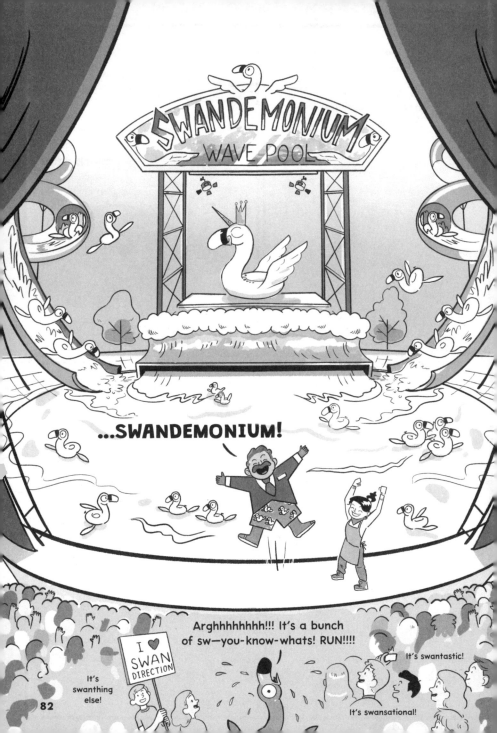

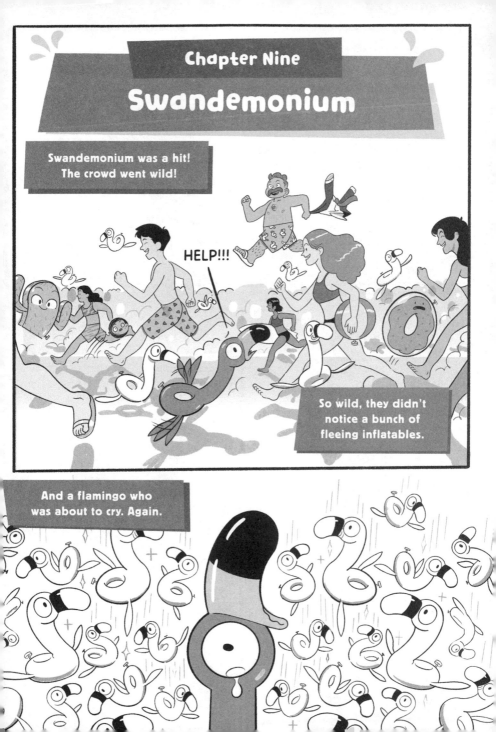

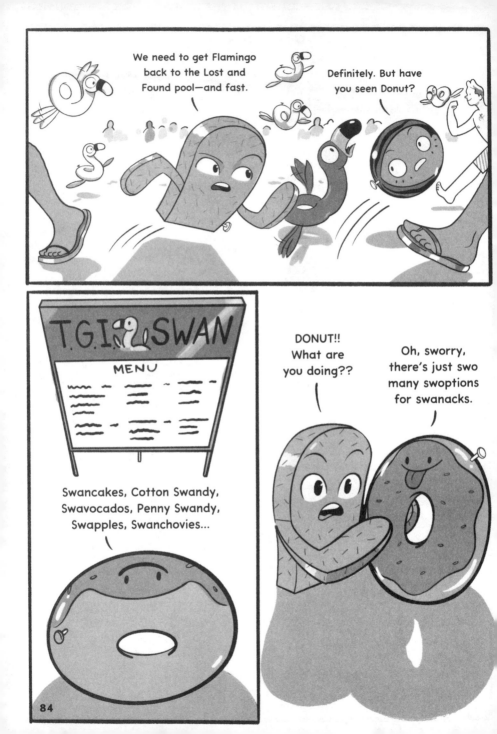

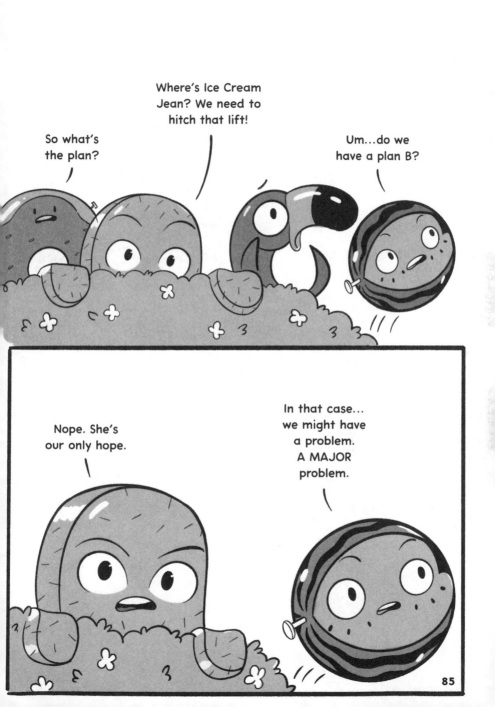

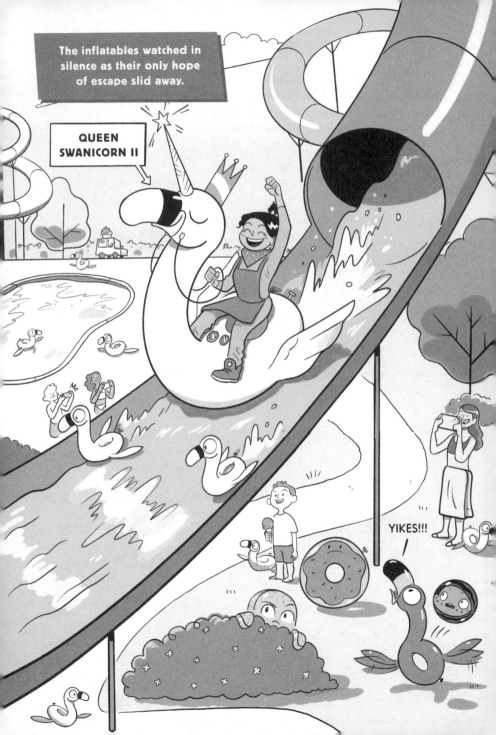

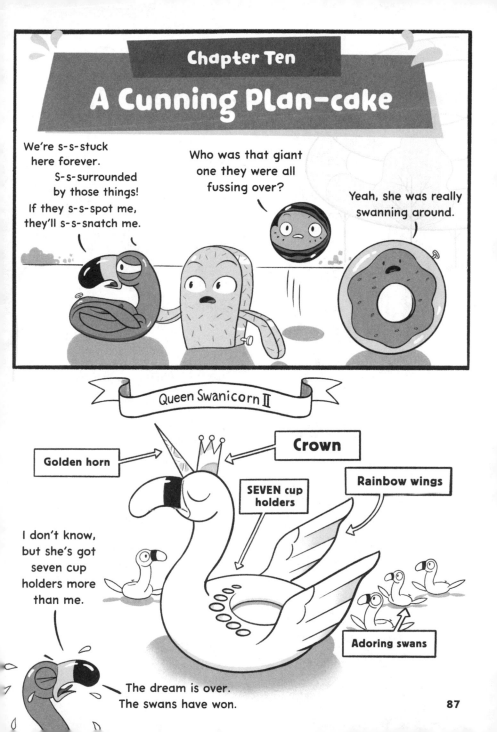

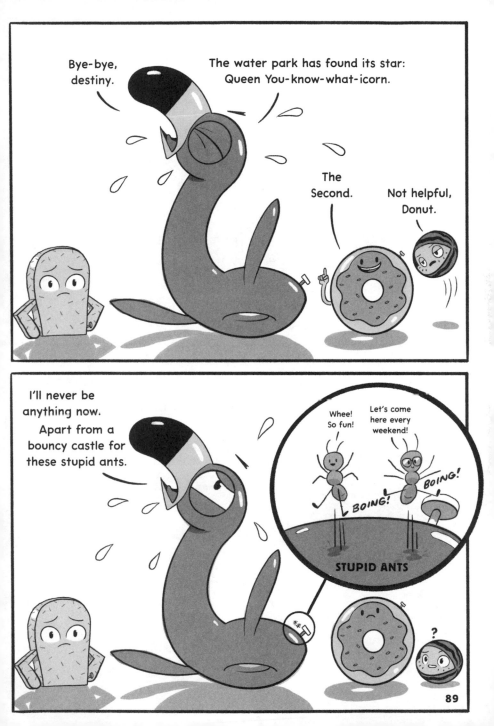

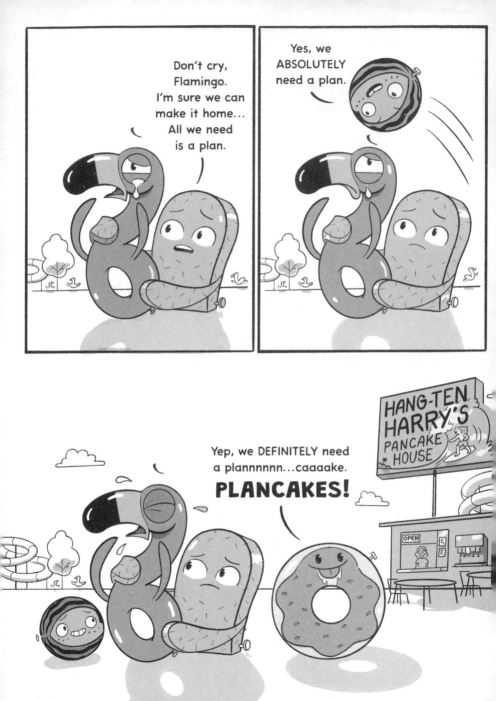

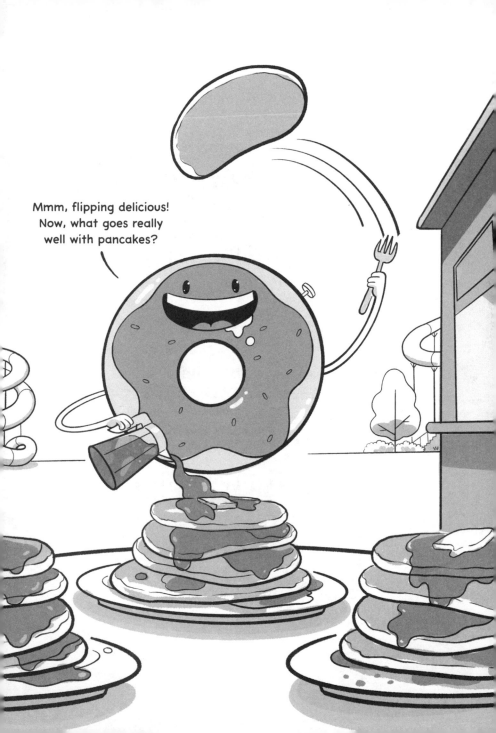

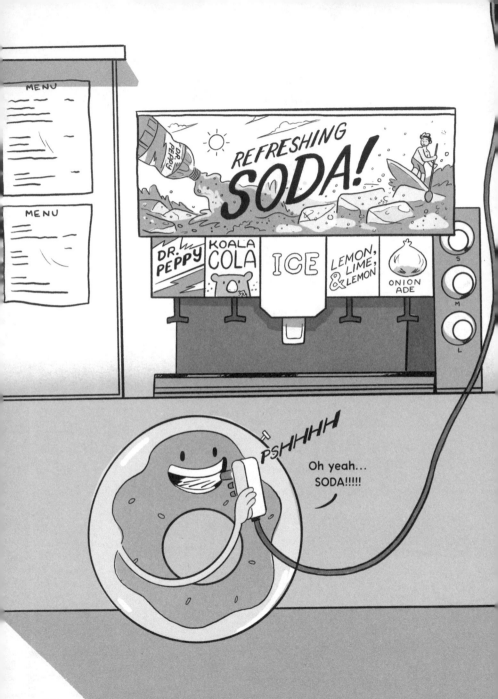

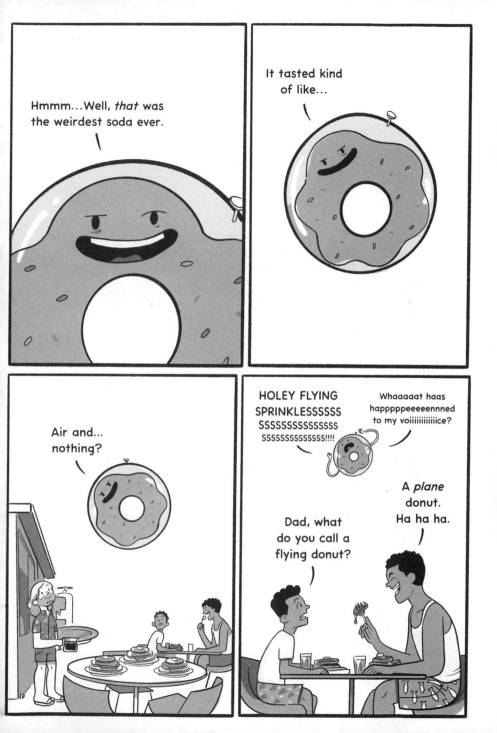

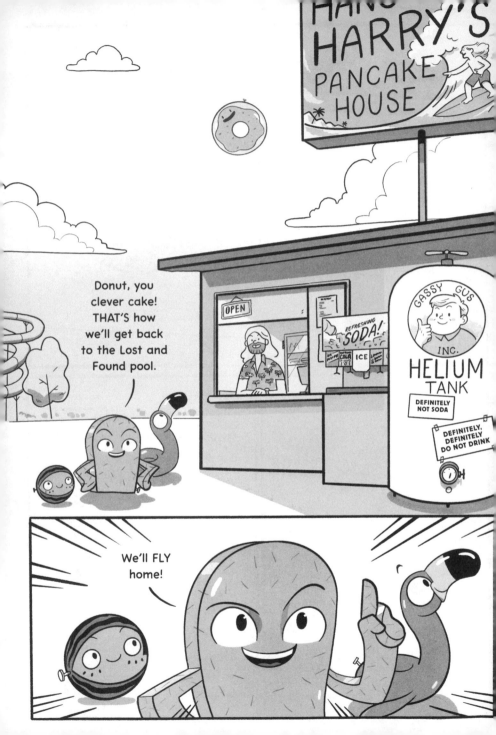

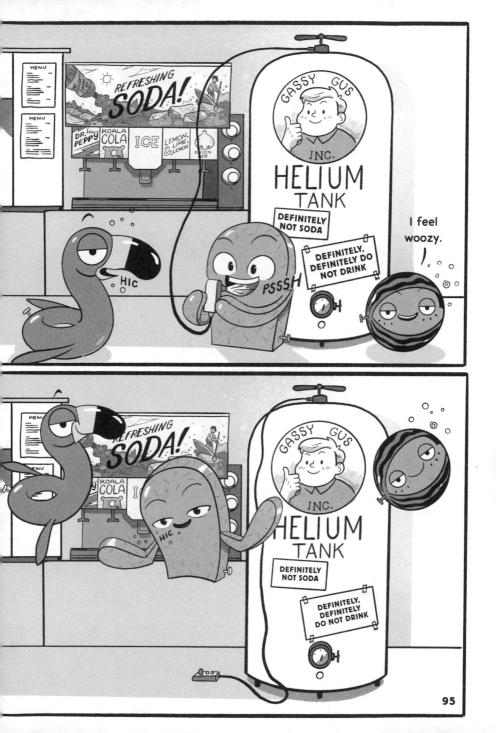

I can't believe you guys. You gave up waves and slides and PopDogs for me. And you didn't complain once.

I don't even need to be a star when I've got friends like you. YOU'RE my destiny.

I promise to be braver next time. For you.

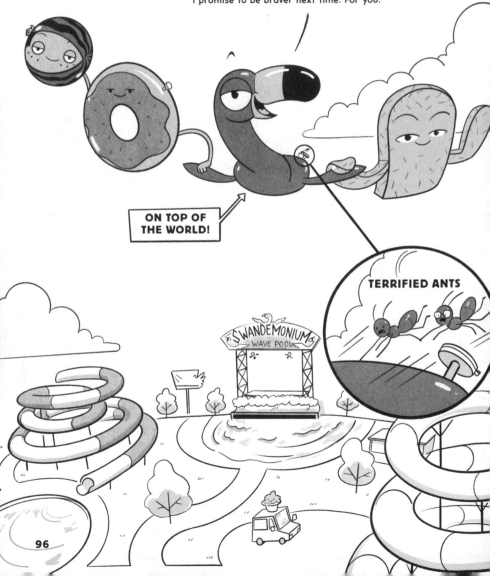

ON TOP OF THE WORLD!

TERRIFIED ANTS

SWANDEMONIUM
WAVE POOL

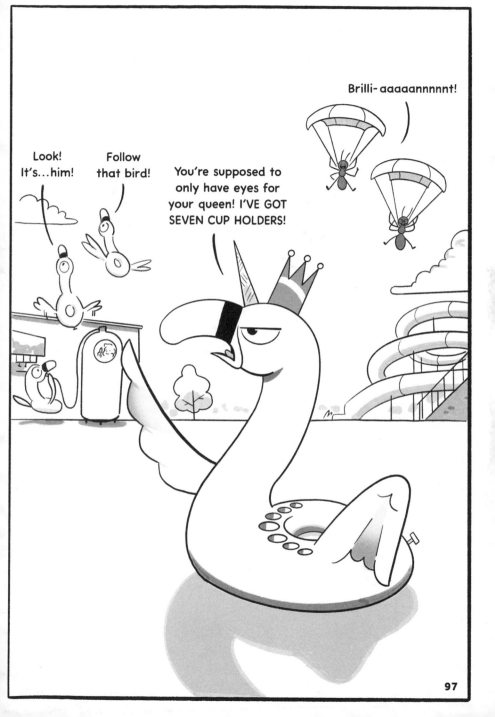

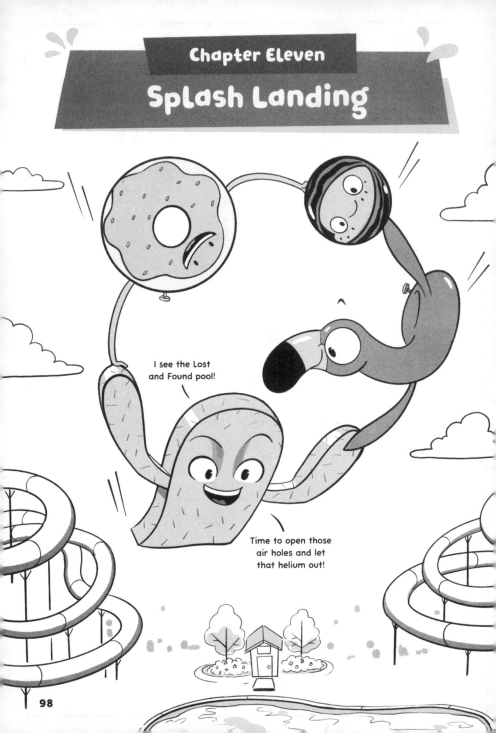

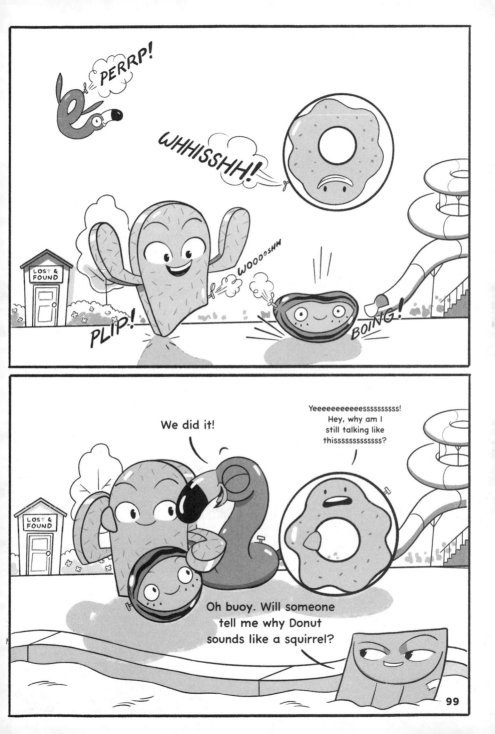

99

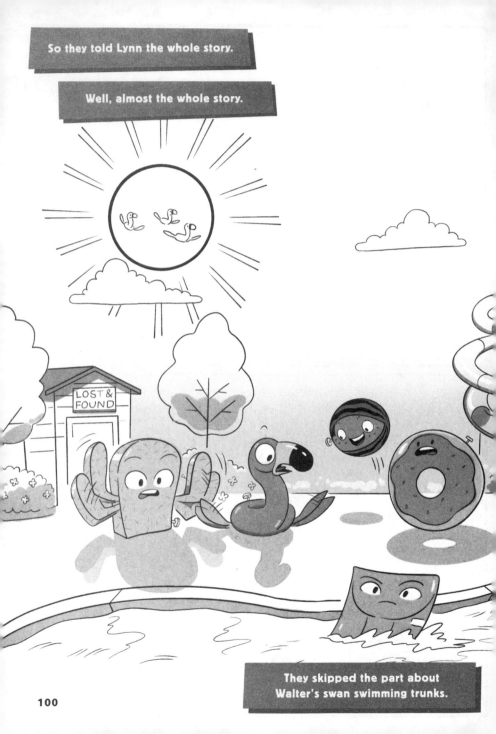

So they told Lynn the whole story.

Well, almost the whole story.

LOST & FOUND

They skipped the part about
Walter's swan swimming trunks.

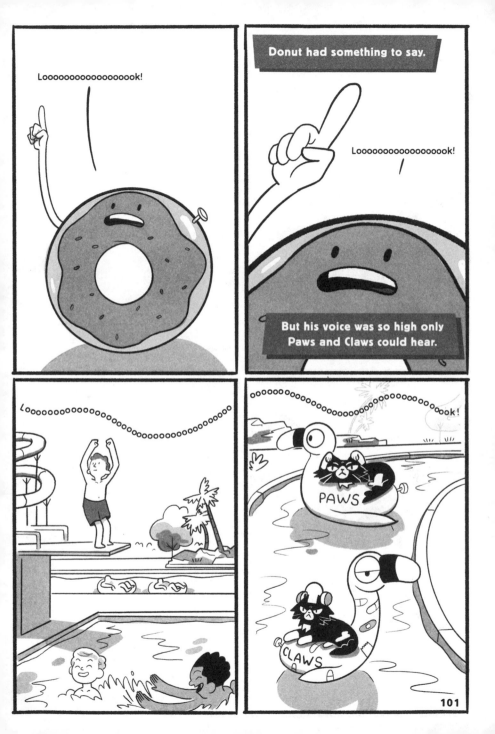

101

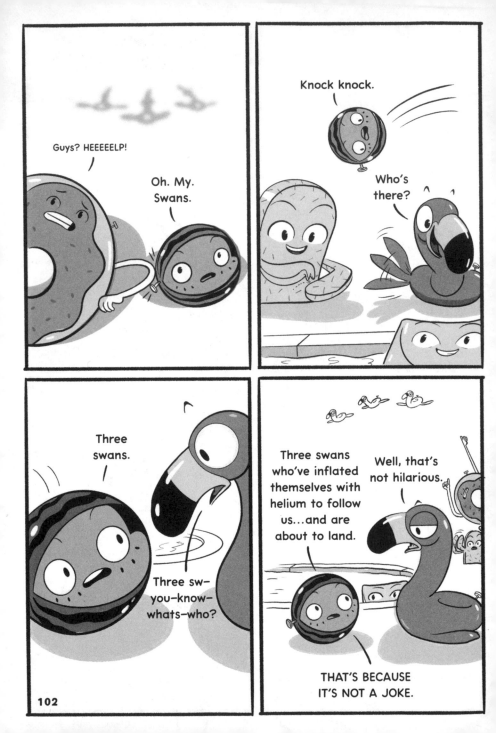

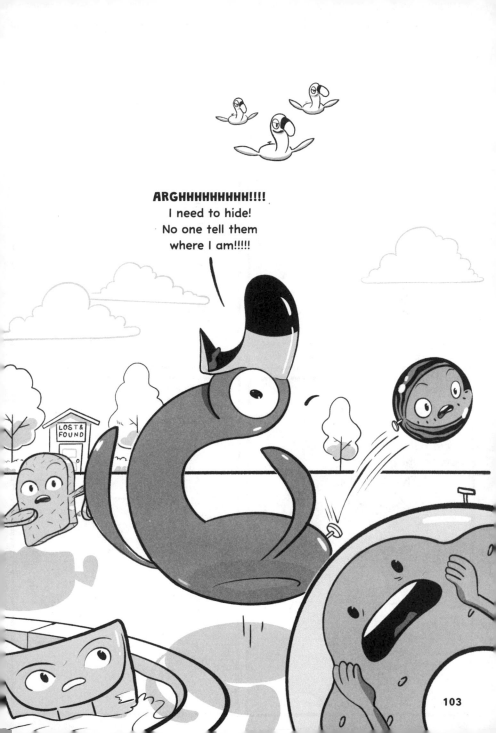

103

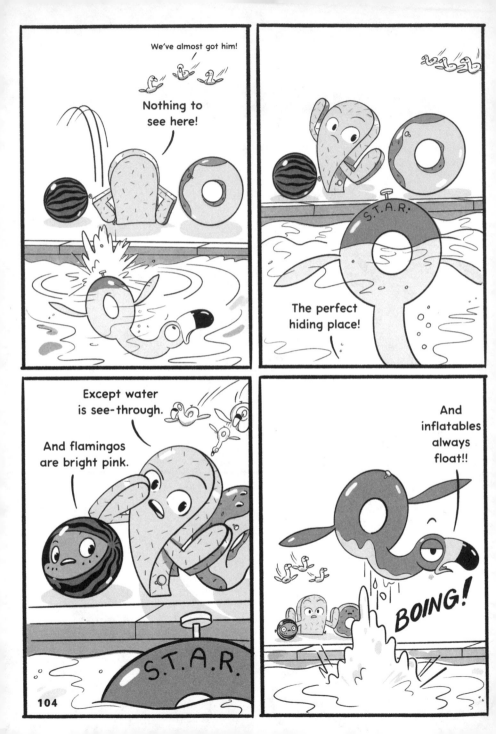

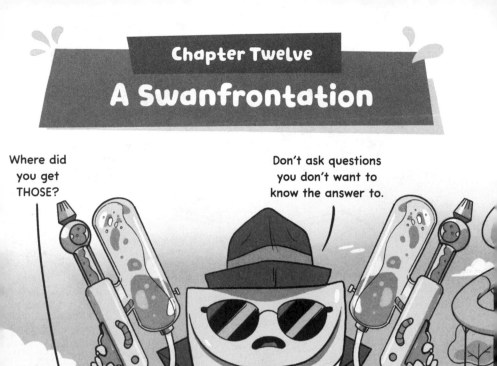

106

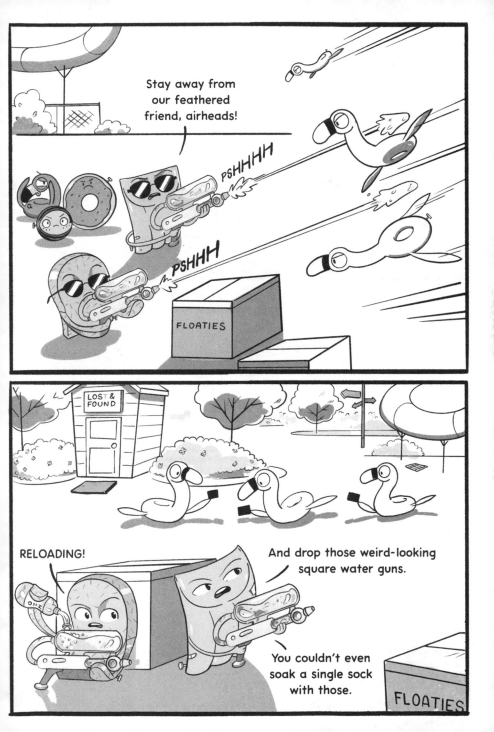

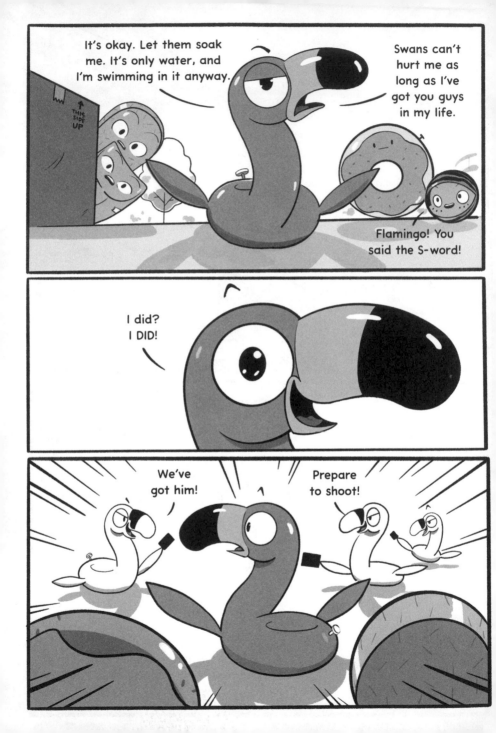

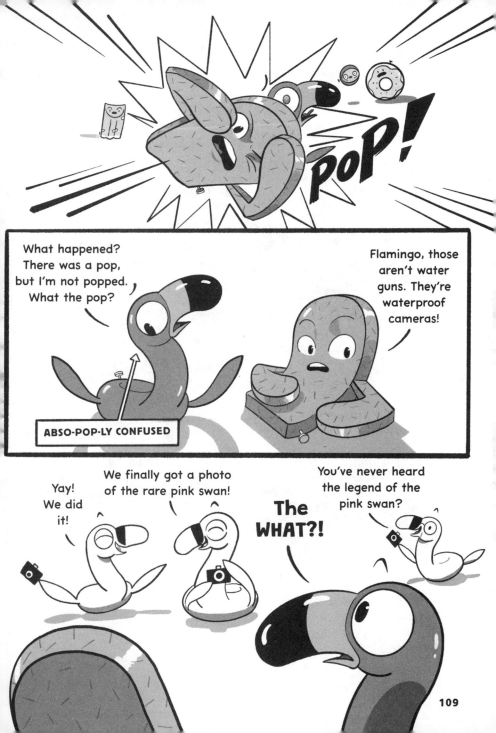

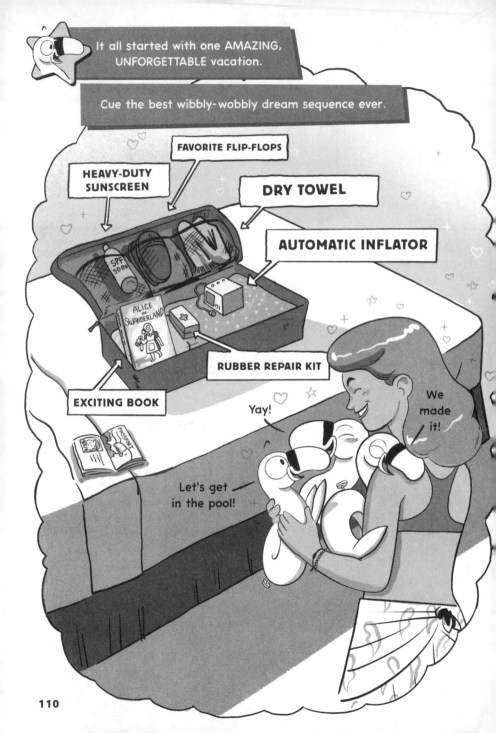

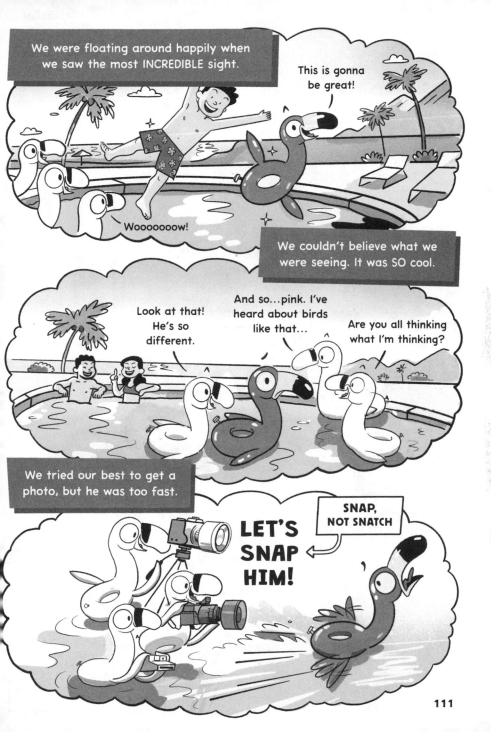

111

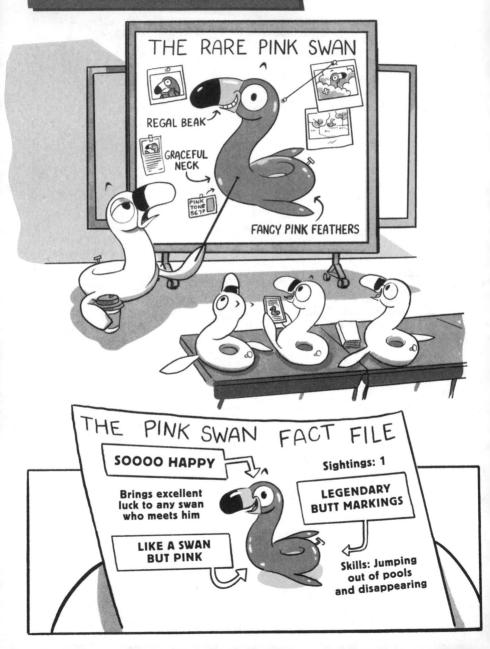

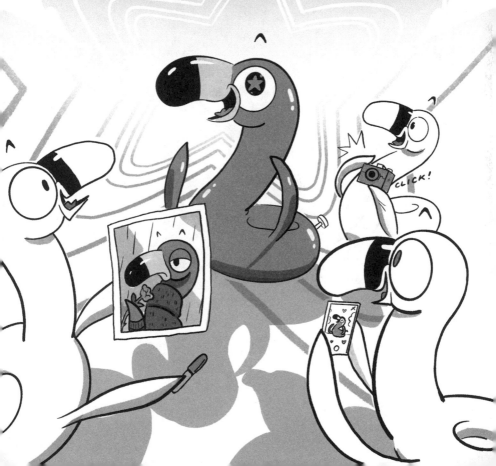

No one has ever seen the pink swan again. Until now...

CLICK!

Guys! All this time you
only wanted photos?!
Why didn't you just ask?

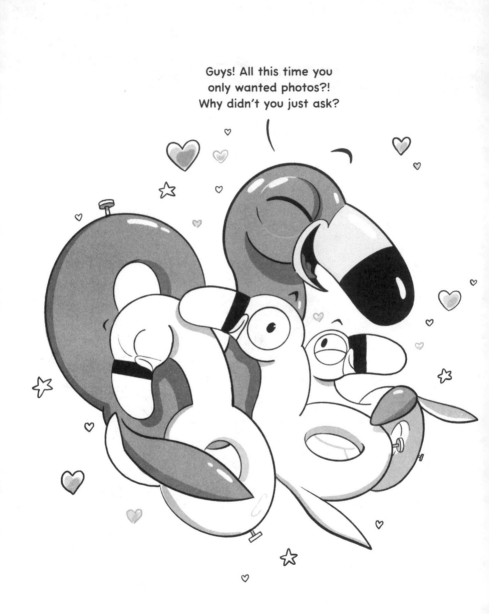

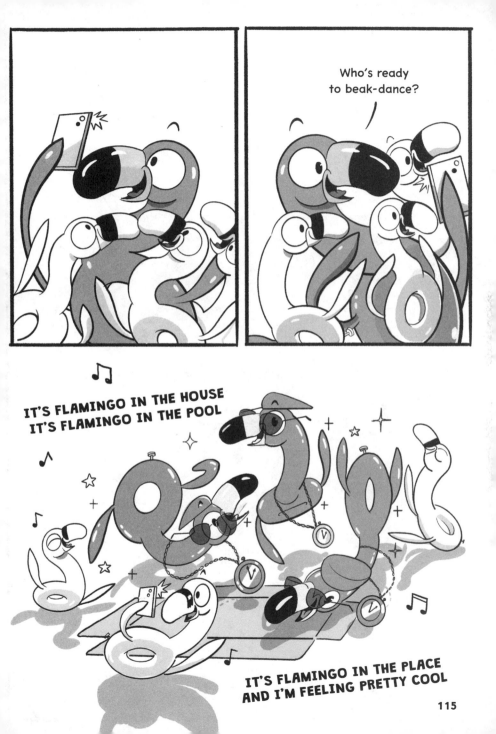

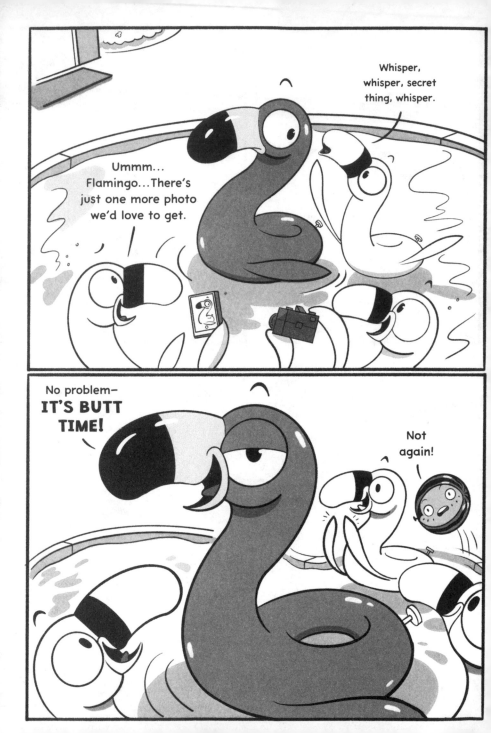

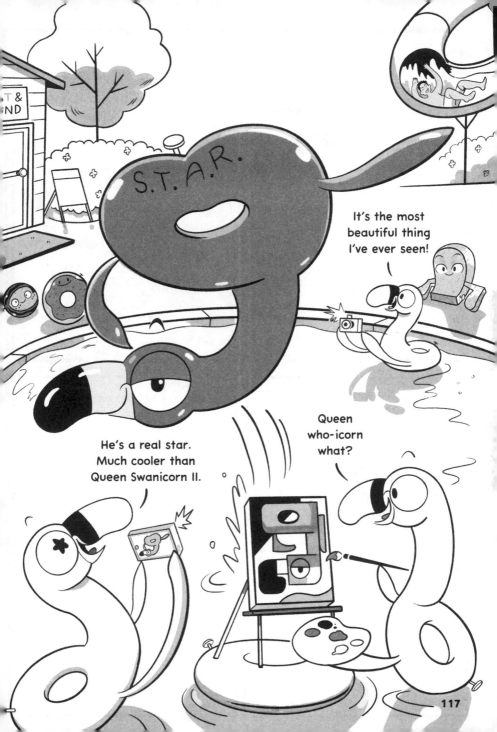

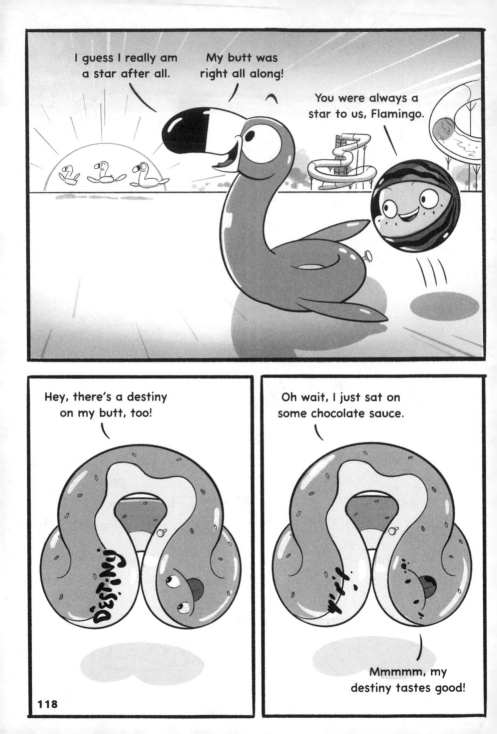

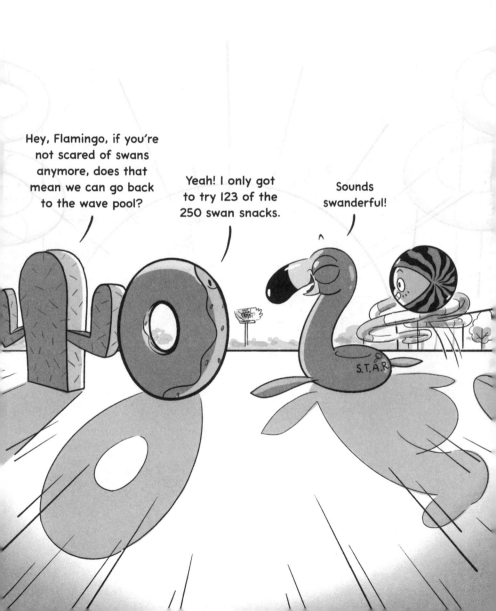

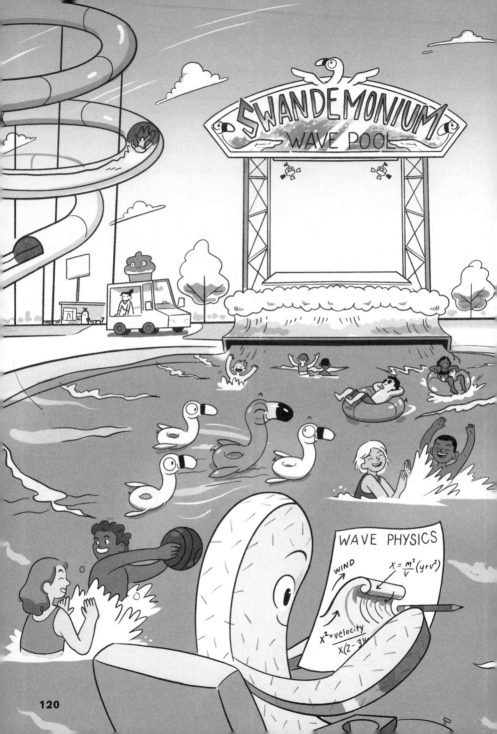

Get pumped for our next air-raising adventure:

MISSION UN-POPPABLE

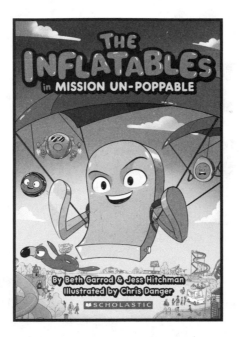

Cactus knows there is something not quite ripe about new float Avocado. So when she discovers he's actually a two-faced Avocadon't and he's planning to take over the park, her mission is clear. But can Cactus convince the inflata-gang to help her stop Avocadon't and save the spray before it's too late?

YOUR FAVORITE BOOKS COME TO LIFE IN A BRAND-NEW DIGITAL WORLD!

- Meet your favorite characters
- Play games
- Create your own avatar
- Chat and connect with other fans
- Make your own comics
- Discover new worlds and stories
- And more!

Start your adventure today! Download the **HOME BASE** app and scan this image to unlock exclusive rewards!

SCHOLASTIC.COM/HOMEBASE

SCHOLASTIC

HBGENERICSP20